BORDERWALL AS ARCHITECTURE

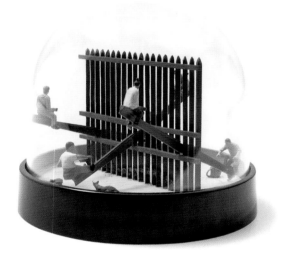

BORDERWALL

A MANIFESTO

LÍNEA DIVISORIA

ENTRE

MÉXICO Y LOS ESTADOS UNIDOS

TRAZADA Y DEMARCADA

POR LA

COMISIÓN INTERNACIONAL DE LÍMITES

SEGÚN LA CONVENCIÓN DE 29 DE JULIO DE 1882

RENOVADA EN FEBRERO 18 DE 1889

Escala 6⁄10000

RONALD RAEL

BOUNDARY
BETWEEN THE
UNITED STATES AND MEXICO
AS SURVEYED AND MARKED
BY THE
INTERNATIONAL BOUNDARY COMMISSION
UNDER THE CONVENTION OF JULY 29ᵀᴴ 1882
REVIVED FEBRUARY 18ᵀᴴ 1889

Scale 6:6000

AS ARCHITECTURE

FOR THE U.S.-MEXICO BOUNDARY

FOREWORD BY **Teddy Cruz**

SECCIÓN MEXICANA

UNIVERSITY OF CALIFORNIA PRESS

For Mattias Miguel Angelo Rael. I hope you always listen and speak to both sides.

ISBN: 978-0-520-28394-7

Library of Congress Cataloging-in-Publication Data

Names: Rael, Ronald, 1971– author. | Cruz, Teddy, writer of foreword.
Title: Borderwall as architecture / Ronald Rael ; Foreword by Teddy Cruz.
Description: Oakland, California: University of California Press, [2017] |
 Includes bibliographical references and index.
Identifiers: LCCN 2016040284 | ISBN 9780520283947 (paper)
Subjects: LCSH: Walls—Mexican-American Border Region. | Border security—Social aspects—Mexican-American Border Region. | Immigration enforcement—Social aspects—Mexican-American Border Region. | Mexico—Emigration and immigration. | United States—Emigration and immigration.
Classification: LCC F787 . R33 2017 | DDC 972/.1--dc23
LC record available at https://lccn.loc.gov/2016040284

University of California Press, one of the most distinguished university presses in the United States, enriches lives around the world by advancing scholarship in the humanities, social sciences, and natural sciences. Its activities are supported by the UC Press Foundation and by philanthropic contributions from individuals and institutions. For more information, visit www.ucpress.edu.

Nadine Little, Senior Editor
Jack Young, Editorial Coordinator
Janet Villanueva, Production
 Coordinator

The publisher gratefully acknowledges the generous support of the Art Endowment Fund of the University of California Press Foundation and the Graham Foundation for Advanced Studies in the Fine Arts.

Copyedited by Barbara Armentrout
Designed and produced by Joan
 Sommers and Amanda Freymann,
 Glue + Paper Workshop, Chicago
Index by Lydia Jones
Color separations by Embassy
 Graphics
Printed in China through Asia Pacific
 Offset

Contents

Every wall is a door.

—**Ralph Waldo Emerson**

Borderwalls as Public Space?

TEDDY CRUZ

There continues to be an inability to envisage the problems facing our societies today in a political way. Political questions always involve decisions, which require us to make a choice between conflicting alternatives. This incapacity to think politically is due to the uncontested hegemony of liberalism, which has reinstalled a rational and individualistic belief in the availability of a universal consensus as the basis for liberal democracy, negating antagonism and conflict. This kind of liberalism is unable to adequately grasp the pluralistic nature of the social world, with the conflicts that pluralism entails: conflicts for which no rational solution can ever exist.

The belief in the possibility of a universal rational consensus has put democratic thinking on the wrong track. Instead of designing the institutions which through impartial procedures would reconcile all conflicting interests, the task for democratic theorists and politicians is to envisage the creation of a vibrant "agonistic" public sphere of contestation where different hegemonic political projects can be confronted.

—**Chantal Mouffe**[1]

Zones of Conflict as Urban Laboratories

The celebrated metropolitan explosion of the last years of economic boom also produced in tandem a dramatic project of marginalization, resulting in the unprecedented growth of slums surrounding major urban centers, exacerbating the socioeconomic and demographic conflicts of an uneven urbanization, an urban asymmetry that is at the center of today's crises. Not only did the so-called global city become the epicenter for the brand of greedy capitalism that caused this new version of the crisis, but it is here where we find the DNA of a selfish, oil-hungry urbanization that detonated an exclusionary sprawl, based on the privatization and erosion of public culture and resources worldwide.

The political economies of division produced in these global zones of megaurban development, which further polarize enclaves of wealth and sectors of poverty, are ultimately amplified and physically inscribed in specific regional junctures such as the San Diego–Tijuana border territory, producing, in turn, local zones of conflict. These geographies of conflict serve as complex environments from which to recontextualize the abstraction of globalization by engaging the specificity of the political inscribed in these physical territories: a *radicalization of the local*. Therefore, this border region has been one of the most productive zones for my research in the last years, enabling the recoding of urban intervention by engaging the spatial, territorial, and environmental collisions across critical thresholds, whether global border zones or the local sectors of conflict generated by discriminating politics of zoning and economic development in the contemporary city.

The Political Equator

I produced the Political Equator to problematize these local-global correspondences and imagine new conceptual frameworks to further engage geographic conflict as an operational artistic tool and as a practice diagram for my work at the border. Using the Tijuana–San Diego border region as a point of departure, the Political Equator traces an imaginary line along the U.S.-Mexico continental border and extends it directly across a world map, showing a corridor of global conflict between 30 and 35 degrees north. Along this imaginary border encircling the globe lie some of the world's most contested thresholds, including Tijuana–San Diego, the most intensified portal for immigration from Latin America to the United States; the Strait of Gibraltar, where waves of migration flow from North Africa into Europe; and the Israeli-Palestinian border that divides the Middle East.

But this global border, forming a necklace of some of the most contested checkpoints in the world, is ultimately not a "flat line" but an operative critical threshold that bends,

fragments, and stretches in order to reveal other sites of conflict worldwide where invisible transhemispheric sociopolitical, economic, and environmental crises are manifested at regional and local scales. The Political Equator has been a point of entry into many of these radical localities, other marginal communities and neighborhoods distributed across the continents from which to imagine new forms of governance and urbanization, arguing that some of the most relevant projects forwarding socioeconomic inclusion and artistic experimentation will not emerge from sites of economic abundance but from sites of scarcity, in the midst of the conflicts between geopolitical borders, natural resources, and marginal communities.

Transborder Itinerant Dialogues

I began to curate the Political Equator meetings in 2006 in order to transform these localities of conflict into operational public spaces from which to visualize the mechanisms that have produced the jurisdictional and institutional conflicts at the center of today's urban crisis. These meetings have taken the form of nomadic urban actions and debates involving institutions and communities, oscillating across diverse sites and stations between Tijuana and San Diego. These conversations on the move have proposed that the interdisciplinary debate takes place outside the institutions and inside the actual sites of conflict, enabling the audience to be both witness and participant. The meetings unfold around a series of public works, performances, and walks traversing these conflicting territories and serve as evidentiary platforms to recontextualize debates and conversations among diverse publics. The main focus has been to link two activist neighborhoods adjacent to the checkpoint but divided by the borderwall that have been the sites for my research and practice in the last years: San Ysidro on the U.S. side, which is the first immigrant neighborhood inside the United States, and Laureles Canyon in Mexico, the last slum inside Latin America on the way to the United States, an informal settlement, home to approximately 85,000 people literally crashing against the borderwall.

While the global city became dependent on a top-down urbanization of *consumption* in the last years, many local neighborhoods on the margins of such centers of economic power unfolded as bottom-up urbanizations of cultural and socioeconomic *production*. It is within these marginalized, underrepresented communities where people, pressed by socioeconomic injustice, are pushed to imagine and produce "other" arrangements, "other" spaces and institutional protocols, "other" citizenships. It is in the periphery where conditions of social emergency are transforming our ways of thinking about urban matters and the matters of concern about the city. The Political Equator meetings have

been, therefore, focused on the specificity of these two border communities, generating a series of cultural and knowledge exchanges, coproduced in collaboration with the two main local, community-based NGOs that represent these neighborhoods: Casa Familiar in San Ysidro and Alter Terra in Laureles Canyon.

The Political Equator 3: Border-Drain Crossing

The Political Equator 3 meeting took place in June 2011. This time, the itinerant conversation mobilized the audience from San Diego into Tijuana through an estuary on the U.S. side (the Tijuana River Estuary), which is adjacent to these border neighborhoods.

This sensitive environmental zone at the edge of the borderwall has been impacted in recent years by the presence of Homeland Security, as the United States has been building the "third borderwall" and other infrastructures of control. After 9/11, in fact, Homeland Security claimed a 150-foot-wide linear corridor parallel to the borderwall as its own jurisdiction to build a "highway of surveillance." Along this territory, the U.S. Border Patrol has been systematically building a series of dirt and concrete dams and drains that truncate the many canyons that move south to north as part of the binational watershed system between Tijuana and San Diego, further physicalizing the collision between natural and administrative boundaries between the ecological and the political. The informal settlement of Los Laureles in Tijuana is located in one of these canyons that shed directly into the estuary, across the wall, in San Diego. Because Laureles is at a higher elevation than the estuary, the construction of the new borderwall has accelerated the flow of waste from the informal settlement into the estuary, dumping tons of trash and sediment, siphoned through the border drains every rainy season, and contaminating one of the most important environmental zones in the region. This territorial conflict served as the main organizing tool for the Political Equator 3, provoking a new dialogue between the municipalities of these two border cities around these issues of mutual interest.

The most emblematic public action during the trajectory of the Political Equator 3 was an unprecedented public border crossing through one of these drains, a culvert in an earthen wall recently built by Homeland Security—located at the actual intersection between the wall, the informal settlement, and the estuary—enabling the audience to slip uninterrupted from San Diego into Tijuana, from the Tijuana River Estuary on the U.S. side into Los Laureles Canyon. A fundamental reason for these nomadic events across the border is to organize and strategize public performances that can infiltrate into sites of exception, encroaching into official institutional protocols and jurisdictional zones. The access to

this impenetrable, militarized zone resulted from a long process of discussions and nego-
tiations with both Homeland Security and Mexican Immigration, requesting the recoding
of this specific generic drain beneath one of those dirt berms as a temporary but official
port of entry for twenty-four hours.

A significant part of this strategy, through our negotiations with the Border Patrol, was
to camouflage this event as an "artistic performance," while implicitly orchestrating the
visualization of the collision between environmental zone, surveillance infrastructure,
and informal settlement and bringing together local, national, and international activ-
ists, scholars and researchers, artists, architects and urbanists, politicians, Border Patrol,
and other community stakeholders who represent the many institutions that have an
antagonistic role around this site of conflict. After realizing that we were not asking per-
mission to enter the country but to exit, Homeland Security finally granted us permission
to let the audience cross from San Diego into Tijuana via this drain, as long as Mexican
Immigration would wait at the south end of the drain to stamp our passports.

On June 4, 2011, 350 people crossed the drain with passports in hand. As we moved
southbound against the natural flow of wastewater coming from the slum, contaminating
the estuary, we reached the Mexican Immigration officers, who had set an improvised tent
on the south side of the drain inside Mexican territory, immediately adjacent to the flow-
ing murky water. The strange juxtaposition of pollution seeping into the environmental
zone, the stamping of passports inside this liminal space, and the passage from pristine
estuary to slum under a culvert amplified the contradictions between national security,
environmentalism, and the construction of citizenship.

Can border regions be the laboratories to reimagine citizenship beyond the nation-state?
Can a cross-border public and awareness be mobilized around shared interests between these
two cities?

As renewed investment in surveillance infrastructure along the U.S.-Mexico border has
further marginalized the communities adjacent to the borderwall and impacted the
transborder watershed systems that are essential to bioregional sustainability, the con-
tradiction was opened: the construction of imposed borderwalls for the sake of security
only exacerbates insecurity, and these stupid logics of division only threaten to produce
future environmental and socioeconomic degradation. By enabling the physical passage
across this odd section of binational territory, the Political Equator 3 not only exposed
the dramatic collision between informal urbanization, militarization, and environmental

zones, but it also articulated the urgency for strategies of coexistence between these two border communities.

Can we shift our gaze and resources from the borderwall itself and into the slum? Can this poor Mexican informal settlement be the protector of the rich Tijuana River Estuary in the United States?

The Borderwall Is Public

Social justice today cannot be only about the redistribution of resources but must also engage the redistribution of knowledge. One of the most pressing problems today, in fact, pertains to a crisis of knowledge transfer between institutions, fields of specialization, and publics. The Political Equator transforms the borderwall into an urban-pedagogical research project, producing corridors of knowledge exchange linking the specialized knowledge of institutions and the activist socioeconomic and political intelligence embedded within border communities. This implies transforming public space into an experimental platform to research new forms of knowledge, pedagogy, and public participation, whose point of departure is the visualization of environmental and political conflict.

The need to reimagine the border through the logic of natural and social systems is the foremost challenge for the future of this binational region and of many other border regions across the globe. A community is always in dialogue with its immediate social and ecological environment; this is what defines its political nature. But when this relationship is disrupted and its productive capacity splintered by the very way in which jurisdictional power is instituted, it is necessary to find a means of recuperating its agency, and this is the space of intervention that art and architecture practice need to engage today. Can architects intervene in the reorganization of political institutions, new forms of governance, economic systems, research and pedagogy, and new conceptions of cultural and economic production? This cannot occur without expanding and recoding our conventional modalities of practice, making architecture a political field and a cognitive system that can enable the "public" to access complexity, building collective capacity for political agency and action at local scales, and generate new experimental spaces and social programs for the city.

In the last decades we have witnessed the incremental hardening of the legal, social, economic, and physical walls between the United States and Mexico. Our borders have been militarized in tandem with legislation that erodes social institutions, barricades public

space, and divides communities. Such protectionist strategies, fueled by paranoia and greed, are defining a radically conservative social agenda of exclusion that threatens to dominate public life for years to come. In fact, the borderwall is a concrete symbol of an "administration of fear," the most clear evidence of our obsession with private interests at the expense of social responsibility and the erosion of public thinking in our institutions today.

This is how the *public* as an ideal is collapsing within a political climate still driven by inequality, institutional unaccountability, and economic austerity. In other words, as the longevity of the welfare-state, top-down public paradigm is in question today everywhere in the world, we need urgently to search for alternatives and a more functional manifestation of public thinking and action at "other" scales, in "other" jurisdictions, and within community-based dynamics: a bottom-up public. The questions must be different questions if we want different answers. This is why one of most relevant and critical challenges in our time is how we are to restore the ethical imperative among individuals, collectives, and institutions to coproduce the city, as well as new models of cohabitation and coexistence in the anticipation of socioeconomic inclusion. The U.S.-Mexico borderwall can be the most strategic pedagogical tool and architectural evidence to rethink resilience and a new regional cross-border public sensibility, based on new strategies of interdependence.

1. Chantal Mouffe, *The Return of the Political* (London, New York: Verso, 2005).

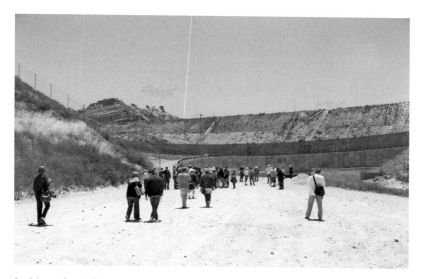

Participants from Political Equator 3 journey southbound against the natural flow of wastewater coming from the slum across an earthen wall built to prevent human traffic through a canyon on their way to cross the border through a drain culvert.

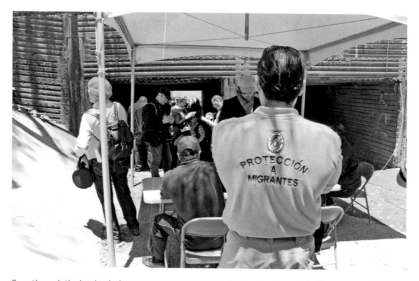

Once through the border drain, passports are checked by Mexican border patrol officers at a makeshift port of entry.

This book would not have been possible without the support, insight, vision, and advice of many individuals. Especially the inspiring minds of the students of the University of California, Berkeley to whom I first posed difficult questions regarding the borderwall in a graduate design studio in 2008, Borderwall as Architecture: Edwin Agudelo, Matthew Bitterman, Maria Chavez, Namrata Kapoor, Gabriella Karl, Tanaz Modabber, Unchung Na, Adriana Navarro-Sertich, Lubaina Rangwala, John Voekel, So Rae Yoo, and particularly, Emily Licht, whose contributions as a graduate research assistant helped lay the groundwork for this book. Her contributions were equally important to Borderwall as Infrastructure, the submission to the WPA 2.0 competition, as were those of Brian Grieb, Nicholas Karklins, Plamena Milusheva, Colleen Paz, Molly Reichert, and Harris Feinsod. Their energy, intellects, and perspectives made that an incredible experience, and their influence and work are present throughout this book. Thank you to Lifu Yao, Aine Coughlan, Kent Wilson, Elli Koutselos, Mona Ghandi, Lily Shafroth, Jeff Miner, and Joris Daniel Komen, who assisted me and my studio, Rael San Fratello, with drawings, graphic design, photography, research, fabricating models, and preparing the manuscript for submission. An enormous thanks to Joris whose wide range of talents helped me see the book through to completion.

The support of cityLab at UCLA was instrumental to the work, and I would like to express my gratitude to Dana Huff, Roger Sherman, Tim Higgins, Linda Samuels, and WPA 2.0 jurors Stan Allen, Cecil Balmond, Elizabeth Diller, Walter Hood, Thom Mayne, and Marilyn Jordan Taylor, as well as the National Building Museum.

Additionally, I'd like to express my appreciation to the faculty and staff at the University of California, Berkeley

Acknowledgments

who have supported the work in a number of ways, particularly my colleagues who have shared interest in the topic: Michael Dear, a mentor who encouraged and believed in the work and without whom this book would not be a reality; fellow WPA 2.0 finalist Nicholas de Monchaux, who has always been generous and supportive of this effort; and Andrew Shanken, Greg Niemeyer, Michael Swaine, Ehren Tool, Tom Buresh, chair of the Department of Architecture, and Jennifer Wolch, dean of the College of Environmental Design.

Thanks also go to Leeann Nielsen for her assistance in copyediting the final drafts and to Ana Teresa Fernández, Jenea Sanchez, Pax Harris, Jonathan Crisman, Chris Shelley, Marcos Ramírez, Teddy Cruz, Michael Elmgreen, Ingar Dragset, Glenn Weyant, Enrique Madrid, Mark Glover, Frederick Schwartz, Patricio del Real, Elisabeth Valet, Julie Dufort, Max Pons, Francisca James Hernández, Rosario Mata, Jose Luis Figueroa, David Figueroa, Federico Besserer, Bryan Finyoki, David Gissen, Leopold Lambert, Norma Iglesias-Prieto, Simone Swan, Alex Niemeyer, Scott Summit, Blane Hammerlund, Ballroom Marfa, Sean Anderson, Richard Misrach, David Taylor, and Marcello Di Cintio, whose rich perspectives have enriched this book immensely—thank you.

Special thanks to Ricardo Lopez, Chief Customs and Border Protection Officer and Public Affairs Liaison at the El Paso Field Office, and Bill Brooks, Public Affairs, Customs and Border Protection, Border Patrol in the Marfa Sector.

Thank you to the staff at the University of California Press: Kari Dahlgren, who believed in the work and helped bring it to the press, and Jack Young, Karen Levine, and Nadine Little who helped see the book through to completion. Joan Sommers and Amanda Freymann of Glue + Paper Workshop provided design and production expertise, and Barbara Armentrout deftly handled the copyediting.

The *recuerdos* (drawings, models, renderings, maps, diagrams, etc.) in this book are a product of my creative studio, Rael San Fratello, which I share with the architect and professor Virginia San Fratello, without whom none of this would be possible. Our travels along the border created a lifetime of recuerdos of our own. Asking my seven-year-old son to be patient while I researched, typed, and drew was the most difficult part of this—and I dedicate this book to Mattias for his unyielding love.

This book was made possible by generous support from the University of California, Berkeley and the Graham Foundation for Advanced Studies in the Fine Arts.

Before I built a wall I'd ask to know
What I was walling in or walling out,
And to whom I was like to give offense.

—Robert Frost[1]

Introduction

The Revolting Door

RONALD RAEL

My first encounter with the borderwall between the United States and Mexico came in the summer of 2003. I had moved away from New York after 9/11, and I was invited by the artist Marcos Ramírez ERRE to visit his studio in Tijuana. His directions were simple: "It's the first building on the right just as you go through the revolting door." Having grown up in the linguistic borderlands of a bilingual family, I found it equally plausible that Marcos was either making a shrewd commentary on the door that served as the pedestrian port of entry into Tijuana, or that he simply meant *revolving*.[2] The richness of the ambiguity stayed with me and led me to the idea that architecture—in this case a door in a wall—can be endowed with different meanings, either by accident or by design, and that architectural expression can be at the same time serious and humorous, and a powerful tool in polemicizing an architecture fraught with controversy.

That same summer, I met the architect Teddy Cruz and was introduced to his vision for design that transects the border. Fascinated by his approach of thinking perpendicular to the border, I became interested in the line of the border itself and the diversity of the landscapes it parallels. This eventually led to a journey to explore the borderlands in California, New Mexico, Arizona, and Texas, where my creative practice worked on several design projects in the Big Bend region—projects that always explored the ideas of political, cultural, and material dualities in design

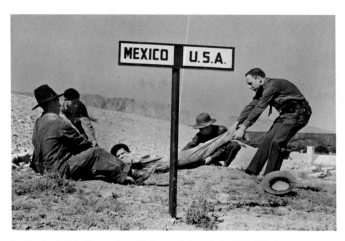

Two Border Patrol officers attempt to keep a fugitive in the United States.

and architecture. At the same time my studio was exploring how to make buildings using mud and concrete (which we saw as conceptually parallel to the contrasts of poverty and wealth, Mexico and the United States, and tradition and contemporaneity,) we also looked at ways in which these material systems—and in many ways, the cultural values and economies of scale embodied by these materials—could be interwoven: two distinct elements working in concert. Some of these ideas culminated in a project entitled *Prada Marfa,* on which we collaborated with the artists Michael Elmgreen and Ingar Dragset. Constructed near the U.S.-Mexico border along a desolate highway in the Chihuahuan desert, a faux Prada store, built of mud and containing the 2004 line of Prada shoes and purses, both epitomizes and exaggerates the cultural and geopolitical dichotomies of the borderlands.

During the construction of *Prada Marfa*, we often witnessed helicopters descending on the horizon to pick up migrants walking through the desert. In fact, during our first visit to the building site for the project, several Border Patrol vehicles blocked our passage and agents surrounded us, demanding to know what exactly what we were doing there.[3] The heightened security in the borderlands, in preparation for the imminent expansion of wall construction, further fueled our desire to consider how design could be a vehicle for addressing the politics of border security.

As a finalist in the WPA 2.0 International Competition, my creative studio was able to explore the possibilities for political expression through architectural design. The competition, organized by UCLA's cityLAB, was inspired by the Depression-era Work Projects Administration (WPA) and the 2009 American Recovery and Reinvestment Act. This stimulus bill (the largest investment in public works in the United States since the 1950s) dedicated $150 billion to infrastructure, and designers were asked to envision a new legacy of publicly supported infrastructure—projects that would explore the value of infrastructure not only as an engineering endeavor but also as a robust design opportunity for strengthening communities and revitalizing cities.[4] Our entry, *Borderwall as Infrastructure*, sought to integrate water, renewable energy, and urban social infrastructure into the design for the borderwall and to challenge the very existence of the wall in its conception, function, and future. At that time, the design proposals suggested an intervention. Since the wall was well on its way to being constructed on a massive scale, the attempt was made to demand wall builders to be more concerned with the landscapes that were about to be divided by the wall, and we made that pitch to lawmakers in Washington, DC, with the proposals. The project was the catalyst for this book; however, this book no longer seeks to intervene in the wall's construction, but instead to consider its transformation—an expanded study on rethinking the existing wall by redesigning it into something that would exceed its sole purpose as a security infrastructure and ameliorate the wall's negative impacts and, perhaps through intervention, make positive contributions to the lives and landscapes of the borderlands.

The work compiled in this book continues the exploration through a collection of anecdotes, essays, models, drawings, stories, and speculations. In addition, short reactions are offered by border scholars that present intimate and diverse perspectives of the wall. This book is also a protest against the wall—a protest that employs the tools of the discipline of architecture manifested as a series of designs that challenge the intrinsic architectural element of a wall charged by its political context. The wall is a spatial device that has been inserted into the landscape, but with complete disregard for the richness, diversity, and complexities of the areas in which it was built and proposed. This book advocates for a reconsideration of the existing wall, both through design proposals inspired by people living along the border who see the wall as something to respond to in positive ways and through proposals that are hyperboles of actual scenarios that have taken and continue to take place as a consequence of the wall.

These propositions presume the somewhat ridiculous reality of nearly 700 miles of border fortification while suggesting that within this enormously expensive and extremely low-tech piece of security infrastructure lie opportunities for the residents of this landscape to intellectually, physically, and culturally transcend the wall through their creativity and resilience. This work is meant to be at once illuminating, serious, and satirical in order to expose the absurdity and the irony of a wall intended to divide but that has brought people and landscapes together in remarkable ways.

1. Robert Frost, "Mending Wall," *North of Boston* (London: David Nutt, 1914).

2. A revolving door in Spanish is *puerta revolvente*. *Revolvente* might easily be misinterpreted as a cognate for *revolting*, because the Spanish reflexive verb *revolver* also can refer to an upset (turning) stomach.

3. An expanded text on *Prada Marfa* can be found in Dominique Molon, Ronald Rael, Michael Elmgreen, and Ingar Dragset, *Prada Marfa* (Berlin: Walther König, 2007).

4. For more information about WPA 2.0, see About WPA 2.0, University of California, Los Angeles, http://wpa2.aud.ucla.edu/info/index.php?/about/about/.

Pilgrims at the Wall

MARCELLO DI CINTIO

Fascinated with the walls we build, I spent much of the last few years traveling along some of the world's most fortified borders. I walked along the barricades that stand between India and Bangladesh, Israel and Palestine, and northern and southern Cyprus. I've toured the misnamed "peacelines" of Belfast and the refugee camps on the wrong side of Morocco's sand wall in the Western Sahara. Each walled place possesses its own brand of injustice and absurdity, but nowhere did the barricades evoke as much sadness as along America's border with Mexico. And nowhere else did the borderlands feel so sacred. America's southern frontier is a kind of holy land.

I met a Presbyterian minister in Douglas, Arizona, who said living on the frontier altered his perception of the Christmas story. Now he sees the birth of Christ as God's migration across the border between the earthly and the divine. Tohono O'odham converts to Catholicism make annual pilgrimages across the border to Magdalena, where they kneel before a statue of Saint Francis Xavier. Until Border Patrol agents led him away in handcuffs one Sunday morning, Reverend John Fanestil used to celebrate Mass on the beach between Tijuana and San Diego and served Communion through the border fence posts. Activists hang crosses from the borderwall to mark those who have perished trying to traverse the frontier.

The border boasts a whole canon of saints, sanctioned and otherwise. Mexican migrants seek help from Saint Toribio Romo, a murdered priest canonized in 2002; devotees believe he appears to border crossers en route and guides them safely through the desert. At Romo's shrine in central Mexico, vendors sell the *Devocionario del Migrante* (Migrant's Prayer Book) filled with verses for migrants to recite during their northward journeys. Tijuana's apothecaries sell clay statues of Juan Soldado, another patron of the migrants. Potential crossers visit

his tomb near the border to pray for safe passage over *la línea*. Border activists in Tucson carry laminated photos of Josseline Jamileth Hernández Quinteros in their wallets like a holy icon. Josseline was a fourteen-year-old Salvadoran girl who died crossing the border in 2008 on her way to meet her mother in Los Angeles. And the Arizonans who demand a stronger, harsher border have their own saint—or a martyr, at least—in rancher Robert Krentz, whose unsolved murder is most often blamed on an unknown "illegal" who made it over the line.

Even the *narcos* have a saint. During a walk along the migrant trails in Arizona, my guide Steve Johnston of No More Deaths paused in front of a small crevice in the rock wall that smelled of burned wax. Soot blackened the tiny cave, and a few charred and broken candleholders lay on the ground. "This was the shrine of Jesús Malverde," Johnston said, "the patron saint of the drug runners." Malverde used to steal horses in the early 1900s and was eventually captured and hanged by Mexican authorities. The narcos later adopted Malverde as their saint. They appreciated his criminal success and, as dope dealers, they related to his name: the word *malverde* means "bad green." The shrine used to feature a painting of Malverde, but Border Patrol agents tore it down. They didn't like the idea of a site where narcos could find spiritual comfort.

The walls wound ancient ritual as well as breed new saints. During my border travels in Arizona, I met Ofelia Rivas, an elder with the Tohono O'odham nation. We sat at her home a few hundred meters from the border and she told me how the borderwall severed the sacred O'odham pilgrimage routes that lead the faithful to ancient holy sites on the other side of the frontier. Before the increased security along the border, the O'odham passed freely back and forth. Now the keepers of the O'odham faith need to face those who hold the line. The Department of Homeland Security has ordered two of the ceremonial routes closed and forces O'odham to make long detours to checkpoints enforced by the Border Patrol. The agents now insist on searching medicine bundles for drugs and contraband. According to O'odham belief, only the celebrants of the O'odham rituals are permitted to handle the sacred items. The border searches pollute the sanctity of the bundles and, according to Ofelia, violate treaty rights of the Tohono O'odham.

Ofelia also told me about the elders who died the year the walls went up. "That year we lost eleven elders. One after another, they passed away. It just seemed like they couldn't comprehend what was happening." Seeing their sacred land bifurcated and dishonored poisoned them somehow. "Almost every month we were having death ceremonies," she told me. "I had longer hair back then, and I kept cutting it to honor the elders who died. By the end of the year, my hair was gone."

As I walked the migrant trails in Arizona, I found the paths strewn with rosaries and votive candles used for mid-voyage prayer. But for the migrants who traverse the harsh holy land of the border, the journey is less a pilgrimage than it is a Passion. Each traveler navigates his or her own Via Dolorosa. The migrants despair and agonize and endure. Some fall and bleed, their knees rasped on rock. They burn in the sun or freeze in the winter desert's chill. Cactus spines and barbed wire stand in for crowns of thorns.

Crossers, though, endure more than these symbolic pricks of flesh. Doctors at the University of Arizona Medical Center treat about forty migrants each year for broken bones and spinal injuries suffered from falls off the borderwalls. There are bullet wounds, too. According to a 2013 investigation by the *Arizona Republic* newspaper, U.S. Border Patrol agents have killed forty-two people since 2005. Some, like the teenager José Antonio Elena Rodríguez, were killed on the south side of the border by American agents shooting through the wall into Mexico.

Female migrants risk a more intimate violence. Border activists speak about "rape trees" in the borderlands of Arizona and California where human smugglers, many connected with Mexican drug cartels, pause their journey to rape their female charges. When they finish, the rapists hang their victims' bras and panties on the branches as a morbid accounting of their conquests.

Other agonies are by design. Back in 1994, the U.S. Border Patrol acknowledged that the concentration of walls and security forces along the urban stretches of the border would funnel migrants into the dangerous desert. A report stated that "illegal entrants crossing through remote, uninhabited expanses of land" could find themselves in "mortal danger." This risk of death, they reasoned, would deter migrants from crossing in the first place. The government, then, aimed to deter migrants by making their journeys deadly. The government turned illegal migration into a crime punishable by death, and the borderlands are a graveyard for those claimed by this cruelty.

Chicana poet Gloria Anzaldúa wrote that the U.S.-Mexico border is the place "where the Third World grates against the first and bleeds." Traveling *along* the fortified line reveals the sadness of the borderlands. Traveling *across* the line, however, is agony. Everyone who braves this ordeal, this geographical self-flagellation, prays for the migrants' brand of redemption at their journey's end: to be delivered from the evil of the border into a land of promise. For this they pray. And for this they are willing to bleed.

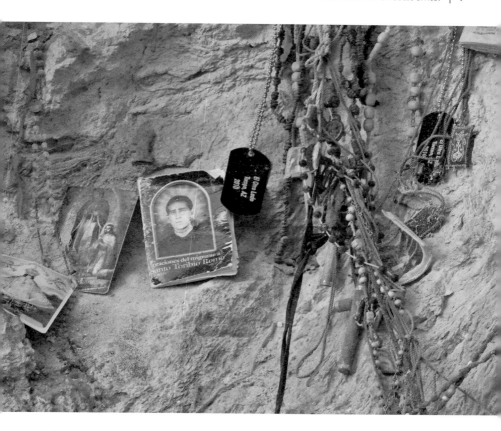

In a "shrine" along one of the migrant trails in Arizona are rosaries, dog tags, and a portrait of Saint Toribio Romo, the patron saint of migrants.

Two

Borderwall as Architecture:
The Divided States of North America

RONALD RAEL

America no longer has the tallest building, but could our planned Mexican border wall be the world's longest building?
—**Stephen Colbert**[1]

Despite recent attention to wall building as a security measure, the building of barriers along the U.S.-Mexico border is not a new phenomenon.[2] After the Treaty of Guadalupe Hidalgo conceived the line defining the United States and Mexico, fences were built along the border for many reasons: to demarcate territory, to keep Mexican livestock out of the United States in order to prevent overgrazing and the spread of disease, and for security. Later, larger fences were implemented in border towns by both the United States and Mexico during the Mexican Revolution and World War I.[3]

However, it was not until the 1990s that major physical transformations began to take place, especially in urban areas, at the border. In 1993, Operation Hold the Line facilitated the construction of lighted barriers in El Paso, Texas, and in 1994, Operation Safeguard extended wall construction in the cities of Nogales, Naco, and Douglas, Arizona, and proposed plans for 225 miles of borderwall in Arizona. Operation Gatekeeper began the militarization of the border in California by directing millions of dollars towards halting "illegal immigration" through several means, including the construction of walls.[4] The Illegal Immigration Reform and Immigration Responsibility Act of 1996 approved the construction of fourteen miles of triple-layered wall near Tijuana, Mexico, and San Diego, California; however, only nine miles were completed by 2004.[5] The attacks of September 11, 2001, pushed the agenda of wall building at the border even further. The REAL ID Act of 2005 waived any laws that would interfere with construction of physical barriers at the border, and a

year later, the U.S. Secure Fence Act of 2006 funded the single largest domestic building project in twenty-first-century Usonia.[6] It financed approximately 700 miles of fortification dividing the United States from Mexico at a cost of up to $16 million per mile.[7] Today, approximately one-third of the 1,954-mile-long border between the United States and Mexico has been walled off. The series of distributed structures is known collectively by several names: the Mexico-United States Barrier, the Great Wall of Mexico, the Border Fence, and the Border Wall.

In some areas, the barrier is a fence (and the U.S. Border Patrol prefers to refer to it as such), but in other places the magnitude and scale of the construction are clearly those of a wall. While the terms *wall* and *fence* may be used interchangeably, there is no question about the spatial, psychological, social, and architectural repercussions of this barrier. As an architectural intervention, the wall has transformed large cities, small towns, and a multitude of cultural and ecological biomes along its path, creating a Divided States of North America, defined by some as a no-man's-land and by others as a Third Nation.[8]

A de facto tabula rasa was created in 2006, when President George W. Bush gave Department of Homeland Security Secretary Michael Chertoff the unprecedented power to waive all laws that could delay the wall's construction. Ultimately, thirty-six laws were waived or suspended to facilitate the construction of the wall, including important environmental, wildlife, and Native American heritage protections.[9] This indifference to the diverse contexts along the border raises critical questions of ecology, politics, economics, archaeology, urbanism, and eminent domain and radically redefines the territories of the *frontera*.

The structure itself is fabricated from steel tubes, barbed wire, recycled railroad tracks, wire mesh, or reinforced concrete—even repurposed Vietnam-era Air Force landing strips are part of the wall's construction. The wall makes use of high-tech surveillance systems such as aerostat blimps and subterranean probes, as well as motion and heat sensors. The concept of "national security" governs and militates the construction and design of the wall, because the success of the wall is measured in the number of intercepted unauthorized crossings. Many types of walls have been constructed along the border. The 700-plus miles of U.S.-Mexico borderwall is organized into single, double, or triple layers depending on the topography, incidence of crossings, available patrol resources, and other factors. In 2008 Congress passed a bill mandating the double-layering of 700 miles of currently single-layer wall, and although the bill died in committee, many single-layer walls have since been doubled. Triple-layer walls define portions of the border between San Diego, California, and Tijuana, Mexico.

The walls found along the southern border of the United States can be defined by the following typologies:

Pedestrian A pedestrian wall is constructed to prevent pedestrian crossings, and many are highly transparent, made with perforated or expanded metal or welded wire mesh, to allow for surveillance through the wall.

Vehicular Vehicular walls can be either temporary or permanent barriers with a heavy concrete base, designed to withstand the impact of a large vehicle. The two most common vehicular wall designs are the Normandy, made with crisscrossed beams, and the Bollard.

Bollard Bollard walls are composed of concrete-filled vertical steel pipes spaced so closely together that a person or a vehicle cannot pass. They may be tall or short, depending on whether their purpose is to stop pedestrians or vehicles.

Hybrid Hybrid walls contain features of both pedestrian and vehicular walls.

Levee Levee walls are used along rivers to control flooding and prevent illegal crossings. They are also a product of international laws that forbid the construction of obstacles in floodplains that could affect the flow of rivers and possibly change the political border, defined in many stretches by the Rio Grande/Rio Bravo.

Natural Homeland Security considers rivers, deserts, extreme temperatures, and rough terrain to be natural barriers.

Virtual Virtual walls employ technologies such as motion detection, radar, sonar, infrared, Wi-Fi, drones, and photography.

Landing Mat Walls of this type were built from surplus Vietnam-era steel landing mats, originally used to create portable touch-down pads for helicopters during the war. This is the oldest type of borderwall still in use today and it is quickly being replaced.

Anti-ram The base of these walls is buried six feet deep in order to deter tunneling, and they can withstand a 10,000-pound vehicle traveling at 40 miles per hour. They are also supposedly quite difficult, if not impossible, to cut.

Floating The floating wall is designed to be constructed atop unstable sand dunes. It can be lifted and repositioned to adjust to the ever-changing topography of dunes.

DIY The U.S. government has not constructed all of the barrier along the border. Private citizens, organizations, and political candidates have all participated in the construction of various homemade barriers. One organization, the Minuteman Project, claimed to have over 1,500 volunteers aiding in the construction of fences along the border. These fences are primarily barbed wire and span only short distances.

Section and elevation drawings of the major wall types.

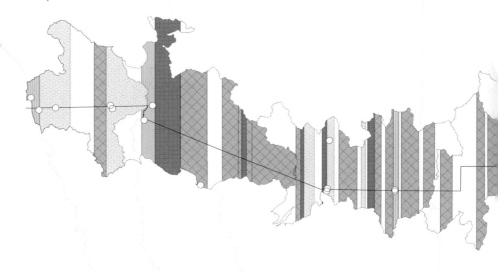

Over 700 miles of barrier have been constructed since 2006, at a total cost of $3.4 billion. A Government Accountability Office (GAO) report in 2011 found that it cost $7.2 million to repair the 4,037 documented breaches to the fence in 2010.[10] In 2007 the construction and maintenance costs had already been estimated to exceed $49 billion over twenty-five years, and several hundred more miles of wall construction continue to be proposed by lawmakers and presidential candidates.[11] It is difficult not to imagine what else an investment of $49 billion could fund along the border when we compare this cost to recent architecture projects, such as New York City's High Line—an elevated vertical public park through Manhattan. With capital expenditures expected to be $90 million for the 1.45-mile project, approximately 725 miles of the High Line could have been constructed along the southern border, nearly the same amount proposed by the Secure Fence Act.

Concrete and steel aren't the only costs incurred on the border; the number of human lives lost in attempts to cross the border is at an all-time high. While recent statistics show a 50 percent drop in the number of people caught illegally entering the United States from Mexico over the past two years, human rights groups put the number of deaths during attempted crossings at its highest since 2006, and nearly 6,000 people have died since 1994.[12]

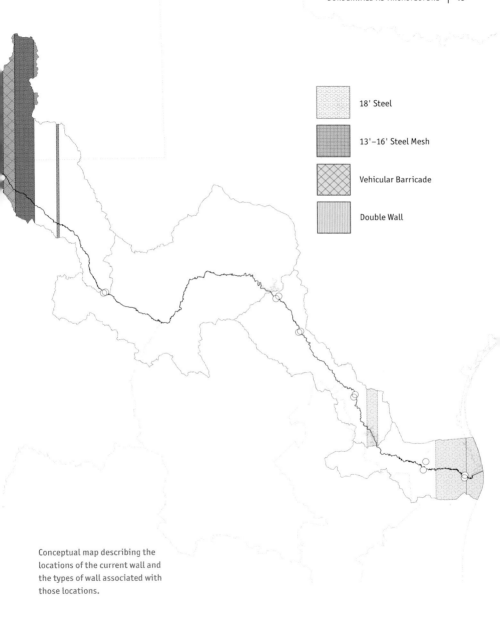

18' Steel

13'–16' Steel Mesh

Vehicular Barricade

Double Wall

Conceptual map describing the
locations of the current wall and
the types of wall associated with
those locations.

For the most part, architects and designers have steered clear of the border security issue. In 2006, the *New York Times* called on thirteen well-known architects to redesign the borderwall. Architect Ricardo Scofidio commented, "It's a silly thing to design, a conundrum. You might as well leave it to security and engineers."[13] Diller+Scofidio and several other architects declined the challenge because they felt it was a purely political issue, something from which many architects shy away.[14]

However perfunctory the proposals were—or even offensive (such as Antoine Predock's suggestion that a 300-foot-wide hot plate be buried under the desert floor to discourage crossings and a massive rammed-earth wall be constructed in the hot sun by "Mexican day laborers")—some did scratch the surface in recognizing the inherent opportunities of the wall as a possible armature for design.[15] In its current state, the wall ignorantly bisects many culturally and environmentally rich places. Therefore, perhaps design offers the potential for the wall to be transformed into a variety of interpretations and applications, ideally ones of benefit to borderland residents.

Architect Rem Koolhaas, who studied the Berlin Wall, has described the peculiarities of the issue:

> I had hardly imagined how West Berlin was actually imprisoned by the Wall. I had never really thought about that condition, and the paradox that even though it was surrounded by a wall, West Berlin was called "free," and that the much larger area beyond the Wall was not considered free . . . [and that] . . . the Wall was not really a single object but a system that consisted partly of things that were destroyed on the site of the Wall, sections of buildings that were still standing and absorbed or incorporated into the Wall, and additional walls—some really massive and modern, others more ephemeral—all together contributing to an enormous zone. That was one of the most exciting things: it was one wall that always assumed a different condition.[16]

The U.S.-Mexico wall has created a territory of paradox, horror, transformation, and flux, like the Berlin Wall did, but on a much larger scale. The wall divides rivers, farms, homes, Native American lands, public lands, cultural sites, wildlife preserves, migration routes, and a university campus.

With the exception of almost two miles of wall accidentally built several feet into Mexican territory, the wall is built on U.S. soil.[17] But in many places, it has been constructed as far as two miles away from the actual territorial border. Estranged from the market economy,

this land between the political boundary of the United States and the security barrier is stripped of its entire productive value. By my estimate, at least 40,000 acres of U.S. land will ultimately lie on the Mexican side of the borderwall—an area twice the size of Manhattan. The pragmatics of the wall as seen through the lens of security requires its form to follow its function as a security infrastructure, but for all the land conceptually ceded to Mexico in a no-man's-land, the wall's form *fallows* the functions of the diverse landscapes it traps behind concrete and steel.

"The U.S.-Mexican border, like most borders," says Noam Chomsky, "was established by violence—and its architecture is the architecture of violence."[18] Many in the discipline suggest that architects should emphatically refuse to participate in the design of architecture that promotes violence. For example, in 2013, Michael Sorkin wrote an essay for the *Nation* calling on architects to refuse to participate in the design of prisons for several reasons:

> disgust with the corrupt enthusiasm and extravagance of our burgeoning "prison industrial complex"; objections to our insane rates of incarceration, our cruel, draconian sentencing practices and the wildly disproportionate imprisonment of minorities. Designing spaces of confinement and discipline is also contrary to what most architects imagine as their vocation: the creation of comfortable, humane, even liberating environments.[19]

The parallels between prisons and the "border industrial complex" are easy to imagine, but can the design at the wall create humane, or even liberating, environments? Architect Lebbeus Woods offered a different approach toward that end. In his project *The Wall Game*, Woods concluded that the only way to address an architecture of violence—in this case, the Israeli Separation Barrier—was to design a means to dismantle it through a complex set of rules that direct architects and builders on both sides to attempt to create a series of constructions on the wall that eventually force it into an imbalance that theoretically topples the wall.

So what are architects to do about the conundrum of the borderwall? Do they ignore the issue altogether or actively protest in refusal to participate? Do they strategize how design might dismantle the existing wall, or rethink the potential of the existing wall as an armature for correcting problems with it? Should they take on the challenge of designing new walls?

Ignoring the issue entirely and designing new walls are perhaps the most contentious strategies. Wall design and construction will, without question, continue, but should it continue without the input of architects? Does refusing to participate in the design of the wall make architects any less complicit in its horrific consequences than participating in its design?

What is immensely clear, now that we are aware of the costs to taxpayers as well as the cost in human lives, is the urgency of reenvisioning the existing wall as something other than an architecture representative of the violence that institutionalized its presence and transforming the wall into an infrastructure that can be put to work. If the wall is not to be dismantled, it should be altered and transformed to serve not only as a security infrastructure but also as a productive infrastructure that would be the very backbone of a borderland ecosystem. Coupling the wall with a viable infrastructure that focuses on water, renewable energy, life safety, and urban social infrastructure is another pathway to security and safety, in both the border communities and the nations beyond them.

According to Border Patrol spokesperson Mike Scioli, the borderwall has a surprisingly limited directive: to serve as a speed bump in the desert, slowing an individual's breach of the border while increasing the Border Patrol's ability to apprehend the would-be crosser. Needless to say, a construction project costing up to $1,325.75 per linear foot should have far more potential than a speed bump. Therefore, it is necessary to retrofit the existing barriers that constitute the U.S.-Mexico borderwall—with schemes that build on existing conditions and seek to ameliorate the problems created by the physical divider. Proposals that intervene in the current U.S.-Mexico boundary would take into consideration three basic premises:

All walls are common walls.

Special laws often govern walls shared by neighboring properties. Typically, one neighbor cannot alter the common wall if it is likely to affect the building or property on the other side. Each wall has two sides, and causing damage to a wall on one side will damage the wall on the other side.

All walls are attractors.

The current borderwall is meant to keep people out and away. Proposals should reconsider the design so that it can serve as an attractor that engages both sides in a common dialogue.

All walls are temporary.

Each proposal should be designed with the understanding that the wall will eventually be removed or reconsidered, creating an even more valuable post-borderwall scenario.

Reconsiderations of the borderwall should focus on public utility–style resources and the creation of social improvements along the border. Social capital—a concept that refers to the value of social relations and the roles of cooperation and confidence in achieving collective and economic results—is produced by networks of people with common interests and is a core element in the fabric of communities. Social capital can yield safety and security, friendship and community, civic identity and economic value, and over time can even build "social infrastructure" in the form of parks and other civic amenities—key elements in the overall health of communities.

One of the most devastating consequences of the borderwall is the division of communities, cities, neighborhoods, and families, resulting in the erosion of social infrastructure. The use of the wall as an armature for infrastructural and social improvements along the border could increase adjacent property values as well as the quality of life on both sides of the border—a necessary step toward immigration reform.

When the wall is carefully reconsidered and reconfigured, it will be able to respond to the complex and often labyrinthine fiscal, cultural, and political realities of the border. Many urban border environments lack the necessary infrastructure to be sustainable, healthy cities, but a borderwall that integrates social, water, and energy infrastructure could conceivably provide these much-needed amenities. Public utility facilities are highly secure areas, and profits from infrastructure development projects can contribute to increased national security and immigration reform through the creation of jobs. To create jobs, the manufacturing of vital components that make up infrastructural technologies could also be located along the border.

Franklin Delano Roosevelt laid out a course for U.S.-Mexico relations at the onset of World War II with a vision of hemispheric security not beholden to a limited view of border fortification. Roosevelt said, "What I seek to convey is the historic truth that the United States as a nation has at all times maintained opposition—clear, definite opposition—to any attempt to lock us in behind an ancient Chinese wall."[20] Yet the border architecture in its current form reflects precisely the inflexibility and ancient strategy of the wall as a singular means of security. Michael Chertoff stated that "a fence by itself is not going to

work, but in conjunction with other tools, it can help."[21] One of those other tools should be design as a reparative measure, and there are many reasons to think that border security can be achieved—and will only be achieved—by employing a more multivalent and flexible tool: a border architecture that has yet to be imagined.

1. Colbert Report, June 25, 2008.

2. During the 2016 presidential campaign, candidate Donald Trump proclaimed that he would, if elected, "build a wall" along the border. While his declaration seemed to excite his audiences as if, finally, someone would build a wall, his call to construct a barrier exemplifies the ignorance of the realities along the border where hundreds of miles of wall already exist.

3. Rachel St. John, *Line in the Sand: A History of the Western U.S.-Mexico Border* (Princeton, NJ: Princeton University Press, 2011), 6.

4. The term *illegal immigration* is widely used to describe the act of unlawful entry to the United States. However, to describe someone as an "illegal immigrant" or an "illegal alien" has become controversial because it is dehumanizing to classify any person as "illegal." It is discriminatory and also confuses the issue of legality because it presumes guilt before a trial has taken place. The Associated Press style book no longer sanctions the use of the term for journalists. See Paul Colford, "'Illegal Immigrant' No More," The Definitive

Source (blog), AP, https:// blog.ap.org/announcements/ illegal-immigrant-no-more.

5. Blas Nuñez-Neto and Michael John Garcia, "Border Security: The San Diego Fence" (CRS Report for Congress no. RS22026, Congressional Research Service, May 23, 2007), https://www.fas.org/sgp/crs/homesec/RS22026.pdf.

6. *Usonia*, a term coined by architect Frank Lloyd Wright, is used here to refer to the two United States of North America: Los Estados Unidos Mexicanos (the United Mexican States) and the United States of America (Los Estados Unidos de América).

7. This information has been updated from Ronald Rael, "Commentary: Borderwall as Architecture," *Environment and Planning D: Society and Space* 29 (2011): 409–20.

8. *Third Nation* is a term coined by Berkeley professor Michael Dear to describe the distinct culture of the borderlands of the United States.

9. Wendy Brown, *Walled States, Waning Sovereignty* (New York: Zone Books, 2010), 36.

10. *Border Security: DHS Progress and Challenges in Securing the U.S. Southwest and Northern*

Borders (Testimony Before the Committee on Homeland Security and Governmental Affairs, U.S. Senate, by Richard M. Stana, Director, Homeland Justice and Security Issues, GAO-11-508T, Government Accountability Office, March 30, 2011), http://www.gao.gov/new.items/d11508t.pdf.

11. Tyche Hendricks, "Study: Price for Border Fence Up to $49 Billion," *San Francisco Chronicle*, January 8, 2007, http://www.sfgate.com/bayarea/article/Study-Price-for-border-fence-up-to-49-billion-2625039.php.

12. Spencer S. Hsu, "Border Deaths Are Increasing," *Washington Post*, September 30, 2009.

13. William Hamilton, "A Fence with More Beauty, Fewer Barbs," *New York Times*, June 18, 2006.

14. In 2016 the Third Mind Foundation announced a competition called "Building the Border Wall?" which drew much criticism among architects. Much of this text grows from my reaction to this competition, which can be found here: http://archpaper.com/2016/03/designing-the-border-wall/.

15. For a concise critical appraisal of the proposals made for the *New York Times*, see Patricio del Real, "Gone Fencing: Architects Tackle the US-Mexico Border," Academia.edu., 2007, https://www.academia.edu/2478419/Gone_fencing_Architects_tackle_the_Us-Mexico_Border.

Predock wrote me apologizing for the offensiveness of his proposal. I recognize that many may also perceive my own work as offensive. Stepping forward with solutions is the intent in both cases, along with the willingness to accept criticism.

16. Rem Koolhaas (interview with Hans Ulrich Obrist), "Part 1: On Berlin's New Architecture," in *Interviews*, ed. Hans Ulrich Obrist, with Thomas Boutoux (Milan: Charta, 2003), 1: 507–28.

17. The two miles of wall were built in 2000 and accidentally encroached up to six feet into Mexico. They cost about $500,000 a mile to construct. Estimates to remove and rebuild these two miles were between $2.5 and $3.5 million. See Alicia A. Caldwell, "U.S. Border Fence Protrudes into Mexico," *Washington Post*, June 29, 2007, http://www.washingtonpost.com/wp-dyn/content/article/2007/06/29/AR2007062901686.html.

18. Noam Chomsky, interview by Graham Cairns, "Hidden Power and Built Form: The Politics behind the Architecture," *Architecture_MPS 3*, no. 3 (October 2013).

19. Michael Sorkin, "Drawing the Line: Architects and Prisons," *Nation*, September 16, 2013, https://www.thenation.com/article/drawing-line-archi-tects-and-prisons/.

20. Franklin D. Roosevelt, "Four Freedoms," in *Great Speeches*, ed. John Grafton (New York: Dover, 1999), 93.

21. While there are a number of architectural definitions for *barrier*, Chertoff describes the intervention as a "tool." Michael Chertoff, *Homeland Security: Assessing the First Five Years* (Philadelphia: University of Pennsylvania Press, 2009), 42.

Three

Transborderisms:
Practices That Tear Down Walls

NORMA IGLESIAS-PRIETO

I once heard a phrase that has remained deeply engraved in my mind and heart. It went something like this: "Walls between nations are the most eloquent material expression of the human inability to coexist and negotiate." Nothing could be more true; the grander the walls, the greater our inability to discuss, negotiate, and resolve common challenges or problems. It should be added that the greater the number and denseness of these walls, the greater our fears and our differences can become. But if fear and mistrust build up walls, they are torn down (literally or metaphorically) by the coexistence, interrelationships, and humanization of neighbors. Humanization processes involve, radically or gradually, reconverting the "other" into an important and intrinsic part of "us," as well as recovering the sense of community and shared space. This process of humanization of the supposed other is not exempt from conflicts and tensions. I am convinced that transborder interactions—despite the difficulties of carrying them out—contribute to questioning and "diluting" borders and, of course, walls. In that sense, I support the postulate that "borders exist or are there to be crossed" because by doing so, we question them and gradually tear them down.

For over thirty-two years, I have watched, crossed, suffered, and reflected on and at the U.S.-Mexican border. The complex and dynamic dailiness of this border (particularly that of Tijuana and San Diego) has become not only my most valued object of study but the greatest challenge that structures my personal, family, and intellectual life. And the metal wall that currently divides the two countries is the element that most surprises me, generates conflict in me, and angers me for what it represents to each country, especially for the damage and discomfort that it generates in the lives of individuals and communities that interact with it. From the Mexican side of the border, the

wall reads like the material and social expression of the geopolitical demarcation, like the most dense and meaningful object that condenses (or contains) all the power asymmetry between Mexico and the United States. From the Mexican side of the border, we are not able to dissociate object from concept. To us, the wall is the border; it is the demarcation; it is the control of the flow and movement of people; it is the limit where the "other side" ends or begins; it is the wait; it is the greatest obstacle in our transborder movement dynamics; it affects us whether or not it is crossed that day because being here or there, it is the wall that always crosses us, affects us, and structures our life.

Throughout history (after 1847), the border demarcation between Mexico and the United States has taken many forms. It went from being an imaginary line marked with some scattered monuments to a light barbed fence, to a wire grid, to a heavy metal wall, until becoming what it is today: a series of aggressive metal fences and enormous concrete posts. It stopped being more of a symbolic marker, which announced the geopolitical boundaries between two nation-states, and became and was naturalized as the major material impediment that inhibits human movement. And I say *inhibits* because its function does not seem to be one of completely stopping the flow of people (as was the case of the Berlin Wall), but of making crossing difficult and discouraging the interaction between people of both sides. In the same way that that object of demarcation has gradually changed shape and density (material and symbolic), so too have the ways that are used to name it. It went from being known in Spanish as *el cerco, la malla, la barda* and became *el muro* (it went from "fence" to "wall").

The different walls put up by the United States government along the border—especially the wall built during Operation Gatekeeper in 1994 with military waste (from the airstrips of the Gulf War, or Operation Desert Storm), with all the heavy symbolism that represents—constitute the ultimate expression of control and border tension. The metal wall is something familiar on the south side of the border; it is part of the urban landscape with which people learn to live, but it does not cease to offend on a daily basis. It is experienced as the object that represents the power of the United States and the lack of respect for the human rights of migrant workers. It is an object that, from Mexico, alludes to an apparent double standard in the United States, since it is argued that it seeks to stop the action of the illegal crossing of people, while advantage is taken from the economic benefits of a cheap and vulnerable labor force. The wall reminds us every day of the high number of Mexicans who die in their attempt to cross into the United States.

By contrast, from the United States, the wall is physically and symbolically distant from the dynamics of life; few know it and fewer have seen it, touched it, or been affected by it in their daily routine. No one has died from crossing it southward. However, the wall is an important part of the social imaginary in the United States; it is an amorphous idea that represents—together with U.S. institutions and policies for immigration and border control—the guarantee of the territory's protection. Thus, the wall or fence symbolizes offense (off-fence) on the Mexican side of the border, while it symbolizes defense (de-fence) on the U.S. side.

Of course, the material and symbolic form of the wall is always accompanied by different ways of interaction and border and transborder practices, as well as different ways of thinking about the neighbors. That is, there is a link among the object of demarcation, the possible type of interaction with neighbors, and the meaning of this experience. A demarcation without fences invites us not only to cross, but it makes us feel part of a regional community, of a shared space. A wire emphasizes a demarcation, but it allows one to see and interact with neighbors. A solid and high metal wall makes it impossible to see and interact with neighbors, and it also sends danger signs, generates fear, and naturalizes mistrust.

The highest level of fear and mistrust is the one being felt today. An obvious example is illustrated by "Friendship Park" (in Border Field State Park), which is experiencing the greatest controls in its history. This binational park is located on the west corner of the border between San Diego and Tijuana. The park has a circle shape, with half on U.S. territory and half on Mexican territory. It was built in 1971 to promote friendship and interaction between the neighboring countries. The park has been split on many occasions by the installation of various fences. Despite the fences, families and friends from both sides could interact in the park without having to cross the border. In this park, there were countless parties with guests on both sides, binational NGO meetings, weddings, artistic and political events, religious services, and a long etcetera. People interacted, talked, or hugged, their arms reaching across the fence; they exchanged photos, documents, and music CDs. But the park changed radically in 2009. Nowadays there is no public access to this area or Border Monument #258, because it is controlled and separated by another fence. Only people with a special permit can go there, in groups of twenty-five people maximum, never for more than thirty minutes, and they must always be accompanied and supervised by a U.S. Border Patrol agent. But the most outrageous aspect is that—as if it were a prison—"physical contact with individuals in Mexico is not permitted." Friendship Park has completely lost its original function. It is an example of the level of control and

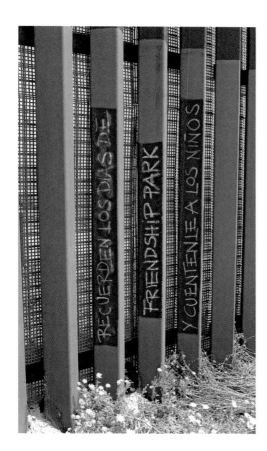

Installation on the wall
reads "Remember the days of
Friendship Park and tell the
children its story."

fear that exists in the United States toward Mexico and of the sense of fear, rather than
opportunity, about its southern border.

We, the thousands of people who cross the border regularly, know from experience that
the more interaction there is, the greater the benefits to both sides. We know that with a
greater level of interaction, there is increased awareness and commitment to the common
good. Transborder dynamics prove daily, and in many ways, that the crossing of people,
goods, ideas, languages, and cultures empowers human capabilities. The history of border
cities between Mexico and the United States has shown that one can live actively and
peacefully without walls. Thus, I bet on transborderisms.

Four

Recuerdos/Souvenirs:
A Nuevo Grand Tour

RONALD RAEL

Spanning almost exactly the distance of the Grand Tour,[1] the tourism route for young male European aristocrats who traveled south from London to Rome, our path leads us on a decidedly different journey—one that stretches for 1,933 miles along the borders of the United States and Mexico. This Nuevo Grand Tour traces the consequences of a security infrastructure that has stood both conceptually and physically perpendicular to human mobility.

Historically, the artifacts that Grand Tourists brought home—books, paintings, and sculpture—symbolized their wealth and freedom. In contrast, along the border, the wall has become a barrier both to the freedom of movement of people traveling north and to their opportunities for improving their quality of life and standard of living, opportunities often unattainable in their points of origin.

On this journey along the physical barrier that divides the United States and Mexico, we encounter a diverse set of experiences, presented here as stories of people transforming the wall on both sides of the border—giving it new meaning by challenging its very existence in remarkably creative ways. To memorialize these events or to expand them we have curated an array of real-life stories, images, and souvenirs, or *recuerdos*—a Spanish term both for the trinkets purchased at tourist shops and for memories.

The recuerdos created for this chapter are unsolicited counterproposals for the wall, both tragic and sublime, that reimagine, hyperbolize, or question the wall and its construction, cost, performance, and meaning. But all are based on our observations, our hopes, and actual events in the liminal space that defines the boundary between the United States and Mexico.

*When one draws a boundary it may be for various kinds
of reasons. If I surround an area with a fence or a line or
otherwise, the purpose may be to prevent someone from
getting in or out; but it may also be part of a game and
the players be supposed, say, to jump over the boundary;
or it may show where the property of one man ends and
that of another begins; and so on. So if I draw a bound-
ary line that is not yet to say what I am drawing it for.*

—Ludwig Wittgenstein[2]

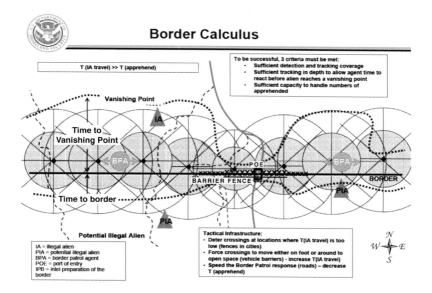

Border Calculus

The Department of Homeland Security has a specific algo-
rithm to determine its allocation of resources including
physical infrastructure such as walls, technology such as
security cameras, and Border Patrol officers. Characterized

1. Border calculus determines
what tactical infrastructure to
use at various locations along
the border, given their geography
and proximity to particular urban
or rural sites.

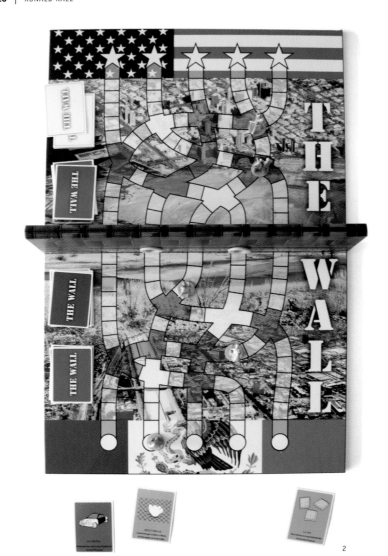

2

2. A board game where strategies of immigration are thwarted by the threats immigrants face on both sides of the wall.

3. Game cards represent the challenges posed to immigrants in their journey from Mexico to the United States.

by its mathematical rigor, the formula is called "border cal-
culus." The strategy implemented in this formula posits that
a successful security infrastructure must meet three criteria.
The first is sufficient detection and tracking coverage. The
second is sufficient "tracking in depth" to allow agents time
to react before an "alien" reaches a vanishing point.[3] The
third is sufficient capacity to handle the number appre-
hended. All tactics take into account specific topographies as
well as the differences between crossings in cities and those
in more remote areas. Ultimately, Homeland Security sees the
wall as a mere five-minute delay—enough to increase its odds
of making apprehensions.

Board(er) Game

The apprehension of immigrants at the wall by the U.S. Border
Patrol agents has been described as a cat-and-mouse game,

but it is much more complex
than that. For many immi-
grants, the wall is just one of a
string of obstacles lining their
migration northward. Rape,
assault, robbery, dehydration,
and exposure to life-threaten-
ing environmental conditions
are a few of the many perils
encountered in a journey to the
wall. Once they are success-
fully across, racism and racial
profiling, undocumented-
immigrant status, poverty, and
run-ins with Border Patrol and
Immigration are all factors that
can send players back to their
starting point behind the wall.

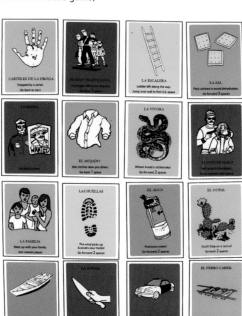

Fence Lab

There are several ways to evaluate how successful the designs proposed for the borderwall may be, and in February 2007, a joint effort called Fence Lab was created to test commercial off-the-shelf and government-designed fencing.[4] Funded by U.S. Customs and Border Protection, Fence Lab was carried out at the Texas Transportation Institute test lab facility at Texas A&M University in College Station, Texas, in partnership with Sandia National Laboratories, the Boeing Company, and the U.S. Border Patrol.

The goal of the design-testing process was to create a barrier strong enough to thwart one of the largest migrations in history from a friendly nation. The U.S. government design requirements mandated that "the fence must be formidable but not lethal; visually imposing but not ugly; durable but environmentally friendly; and economically built but not flimsy."[5] The federal government did not want the new fencing to look like a wall, and according to Peter Andreas, a political science professor at Brown University who studies border-security issues, the government wanted "to make it seem like you could shake hands through the fence."[6]

The eight-week, $12,500-per-day project[7] involved testing eight different fence designs, including pedestrian fences and vehicular fences.[8] Some fences were tested in hand-to-wall combat by a team of U.S. Border Patrol agents physically attacking the barriers with axes, battery-powered saws, grinders, blowtorches, crowbars, and ladders.[9] To the surprise of the engineers, the team of agents quickly dismantled the fences. As a result, new fence designs now specify that hollow steel tubing (easily cut by blowtorch) be filled with concrete to increase the amount of time it takes immigrants to get through. In addition, rectangular posts, which were found to be easy to climb, have been replaced with taller fences with round tubing, which slows down—but does not stop—climbers.

To test the fence's ability to thwart vehicular encroachment, remote-controlled vehicles weighted with 10,000 pounds

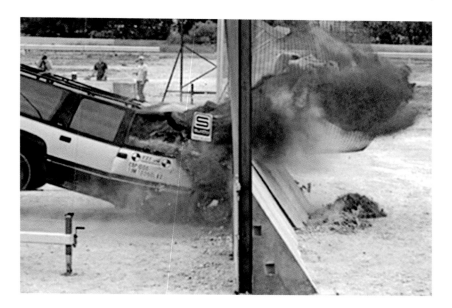

were slammed into fence prototypes at 40 miles per hour.
This set a new standard for "cost-effective fence designs
that could be rapidly replicated" to meet the Border Patrol's
requirement for deterring or slowing pedestrians and vehicles
attempting to cross the border between ports of entry.[10]

4. A remote-controlled vehicle
ramming into a wall prototype at
Fence Lab.

Borderwall Bridges

At the same time that millions of dollars in research and
development were being spent at Fence Lab to create
solutions to prevent border crossings, much research was
also taking place in Mexico to develop low-tech solutions
for breaching the wall. Perhaps one of the most ingenious
methods by which people attempt to cross the wall is with
a portable bridge, a steel ramp that creates a pathway for
automobiles to drive over the fence.

There are several types of moveable bridges. Some are attached to the backs of pickup and flatbed trucks, making them highly portable. Others must be hand-carried and put in place by several people. Both are used to cross the several different types of wall that exist along the border. Ironically, vehicular walls, specifically designed to stop automobiles, are the easiest walls to cross because they are typically quite low, and ramps can be easily placed on both sides, allowing vehicles to drive across them.

Height is not necessarily a deterrent, however. Some surprisingly daring attempts have been made to drive across several of the taller walls, and many borderwall bridges have been discovered after an attempt proved unsuccessful. For example, in 2009, on the Tohono O'odham Reservation near the San Miguel Gate border crossing, a pickup truck carrying 314 pounds of marijuana fell off a steel bridge that had been placed over a vehicular barrier made of railroad ties. When the front wheels became inextricably wedged between the rails of the metal ramp, the owners abandoned the vehicle, which was later discovered by Border Patrol agents.

In 2011 near Yuma, Arizona, Border Patrol agents discovered a 2001 Jeep Cherokee driving at suspiciously high speeds. When agents attempted to stop the vehicle, it changed direction and headed south toward Mexico. On reaching the fence, the vehicle's occupants escaped on foot, circumventing the fence and fleeing into Mexico. The agents discovered 1,000 pounds of marijuana inside the vehicle and later learned that the vehicle had entered the United States by driving over a large ramp placed over the 12-foot-tall borderwall. The ramp, which was permanently attached to a customized truck with its bed removed, could be transported folded in half over itself and later unfolded onto the U.S. side when parked next to the borderwall. Vehicles could drive up the back of the truck, over the wall, and down into the United States[11]—a low-tech version of the armored vehicle–launched bridges that assist military vehicles across rivers.

Several other deployable vehicle-launched borderwall ramps have been discovered. Jeep Cherokees appear to be

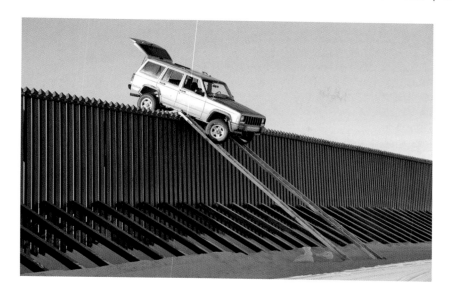

a preferred vehicle for driving over borderwall bridges, and the Yuma Sector a favorite crossing place. In California near Yuma, Arizona, Border Patrol agents discovered a silver Jeep Cherokee high-centered and immobilized at the top of the infamous 14-foot wall crossing the Imperial Sand Dunes (see "Floating Wall"). Makeshift ramps had been placed on both sides of the wall, allowing the Jeep to drive to the top. Despite the Jeep's capabilities as an off-road vehicle, however, this one was found teetering on top of the wall, between the two countries (see "Teeter-Totter Wall").

Although it is not known what the vehicle was carrying, as it was found empty, it is suspected that it was being used to smuggle marijuana and was emptied and abandoned when it became lodged atop the wall. Supervisory Border Patrol Agent James Jacques of San Diego, California, summed up the sight of vehicles driving across the tall borderwalls: "It's like the old show *The Dukes of Hazzard,* cars flying through the air."[12]

5. A Jeep Cherokee that was high-centered in an attempt to drive over the 14-foot Floating Wall; the suspected smugglers fled into Mexico.

Projectiles

Automobiles carrying people and drugs are not the only
things traveling through the air over the wall. During the
Middle Ages, with the rise of fortified castles and city walls,
the catapult became an essential tool to launch objects
and even bodies over protective walls.[13] It was also a time
when the cannon became a standard method of breaching
walls. With the catapult's and the cannon's shared history of
launching humans through the air,[14] it is unsurprising that
these medieval technologies would resurface in reaction
to the anachronistic security barrier along the U.S.-Mexico
border.

Among the projectile launchers created to hurdle the wall
are catapults, used by drug traffickers to hurl marijuana and
other contraband over the borderwall. Packages of mari-
juana are bulkier than heroin or cocaine and therefore more
difficult to smuggle hidden in vehicles or carried by hand. The
catapults confiscated by Mexican authorities are built upon
trailers that can be easily attached to a truck, making them
very portable. These "pot-a-pults," which can be as tall as 9
feet, are constructed with steel and a strong elastic band and
can hurl marijuana bales weighing approximately 4.4 pounds
each. These borderland trebuchets have been discovered in
use along the Arizona-Mexico border near the cities of Naco
and Agua Prieta.

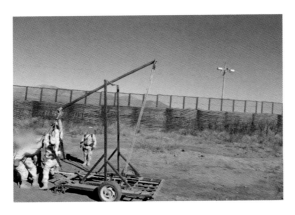

6. Border Patrol agents, working
with the National Guard and
Mexican authorities, discover a
catapult used to launch mari-
juana over the wall.

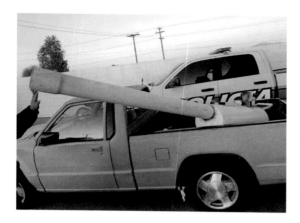

7. An improvised cannon used to launch marijuana over the wall into California.

More powerful are the cannons used to launch packets of marijuana over the borderwall into Calexico, California, from Mexicali, Mexico. These homemade cannons are fashioned from plastic pipe and makeshift metal tanks containing either compressed air (produced by an automobile engine) or encapsulated compressed carbon dioxide. These cannons have been known to fire 30-pound canisters of marijuana up to 500 feet. Thirty-three such canisters, fired out of one of these cannons and valued at $42,500, were recently discovered near Yuma, Arizona.

So, have people also been launched over the wall? An episode of the television program *MythBusters* tested the theory that in addition to drugs, immigrants themselves were becoming human projectiles and being flung 200 yards across the border into the United States.[15] The show constructed a human-sized slingshot to see if it was possible. The tests involved the launch of a mannequin over a fictional U.S.-Canadian border and used a chain-link fence topped with razor wire to mark the border—a vision clearly inspired by the U.S.-Mexico wall. And although the *MythBusters* team was able to propel the dummy 211 feet, it was concluded that it didn't seem possible to launch humans accurately enough to ensure their safety.

(OVERLEAF)
8. Human cannonball David Smith Sr. being launched over the wall from Tijuana into the United States.

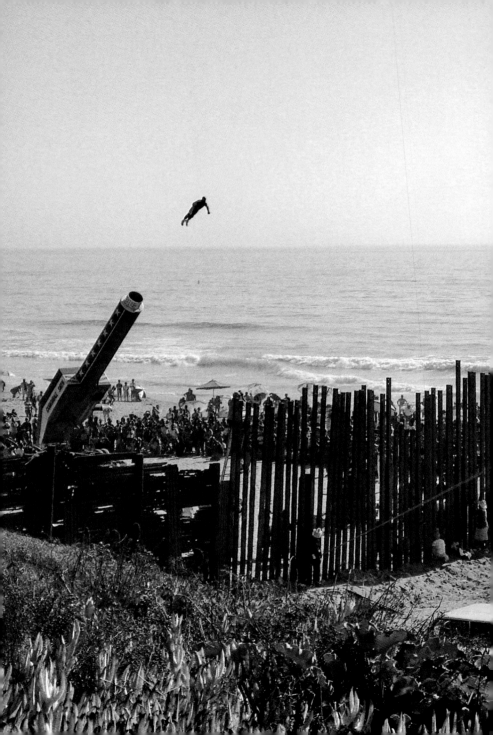

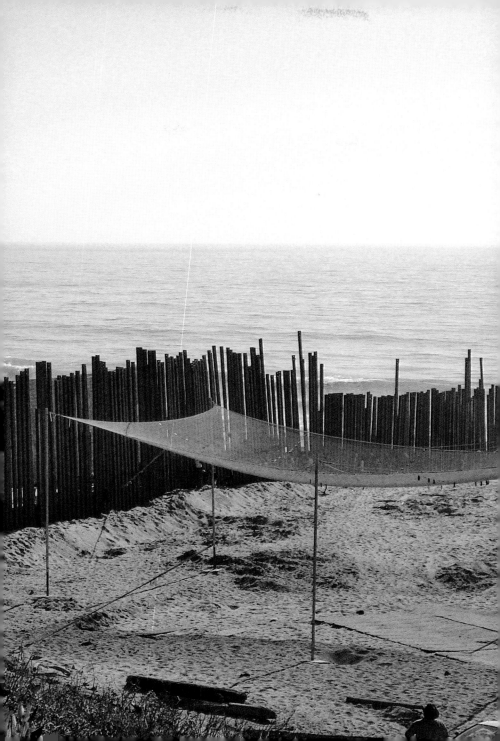

Although there is no evidence that migrants are being launched over the wall, human cannonball David Smith Sr., who holds the distance record for being shot into the air (201 feet, in 2002), is the first person whose launch by cannon over the U.S.-Mexico borderwall has been documented. Although it is illegal to enter the United States from Mexico except at an official port of entry, U.S. Border Patrol Chief David Aguilar granted Smith permission to cross in this unconventional fashion. So, in 2005, with passport in hand (which he waved to the crowd before blasting off from Tijuana, Mexico), he sailed over the wall and landed squarely in a large net awaiting him in San Diego, California.[16]

When Smith was asked why he did it, his reply was simple: "I did it for the money—I get paid!"

Climbing Wall

Former U.S. Secretary of Homeland Security Janet Napolitano said of the borderwall, "You show me a 50-foot wall, and I'll show you a 51-foot ladder at the border," a statement that has become a mantra for describing the wall's inadequacies.[17] Although many new fence types are being designed to be more difficult to climb, through the use of perforated metal or round steel columns, their challenges are often quickly overcome. While it is difficult to insert fingers or toes into perforated metal panels, they can be turned into a climbing surface by using screwdrivers. In a 2010 video that went viral on the Internet, two young U.S. women demonstrated how easily round columns can be climbed, surmounting the wall in less than eighteen seconds.[18]

In 2016, Palestinian artist Khaled Jarrar constructed a ladder out of the wall itself. He ripped away a portion of the borderwall in Tijuana—an 18-foot-long post—and transported it to New Mexico State University, in Las Cruces, where he cut the steel into pieces. He used the pieces to construct a ladder, which he transported to Juarez, Mexico, and had it installed near the borderwall as a monument "to connect communities

9

9. Ladders used to scale the wall are discarded in the Santa Ana Wildlife Refuge.

10. A recuerdo showing a group of climbers enjoying the challenge while an unauthorized climber is detained.

and explore comparisons and common concerns between this wall and the wall I live with every day in my home city of Ramallah, Palestine."[19]

Other ladders, created not by artists but by people using them to easily climb over the borderwall, have been found lying against the wall in piles. Texas ranchers, tired of routinely making costly repairs to fences damaged by immigrants, have gone so far as to install ladders in order to provide easier routes through the fields near the U.S.-Mexican border.[20]

Perhaps the wall itself should be conceived of as a ladder. Rather than perpetuating the illusion that it is difficult to climb, perhaps it should be designed to be intentionally challenging to climb, with the kinds of routes and ratings used for rock-climbing walls in gyms, thus promoting better health and exercise along certain stretches of the border.

10

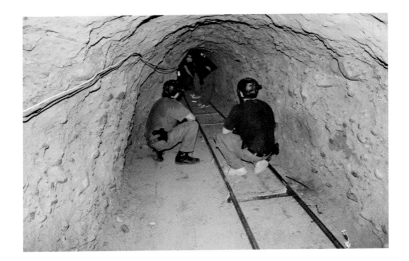

Tunneling

While some smuggling operations aim to go over the wall, a
number of subterranean transborder strategies have been
created to go under it. Since 2006, U.S. law enforcement
agencies have discovered over eighty tunnels along the bor-
der, with most located in California and Arizona. One tunnel
found in Otay Mesa, California, ran for 2,400 feet at a depth
of 70 feet.

11. Electricity and tracks discov-
ered in an Otay Mesa drug tunnel.

Many of these tunnels connect to homes and warehouses on
both sides of the border. Tunnel entrances can be fireplaces,
doors beneath sinks, or removable panels in floors. These
portals lead to underground chambers, some of which are
very sophisticated. With the goal of effectively transporting
people, drugs, and other contraband, some of these passages
include carefully engineered lighting, ventilation, water
drainage systems, and sometimes even railroad tracks with
carts. While walls may seem formidable barriers to some,
they inspire many others to create strategies to bypass the
security measures at the border.

12. An ant farm demonstrates the
efficacy of the borderwall as a
barrier to physical movement.

Bicycle and Pedestrian Wall

If the borderwall is to remain as a barrier preventing north-south traffic, perhaps it can at least facilitate east-west pedestrian and bicycle movement on both sides of the border by being reenvisioned as a linear urban park through certain geographies. Supplemented with green spaces and connected to schools and other parks, the wall could be an ideal organizing condition, as well as physical armature, for an urban park offering pedestrian and bicycle routes through cities. The linear park would have the potential to increase adjacent property values, reduce vehicular traffic, and improve the quality of life on both sides of the border while providing an important green corridor through municipalities.

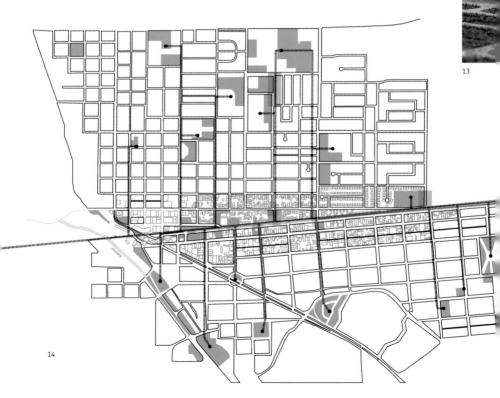

13

14

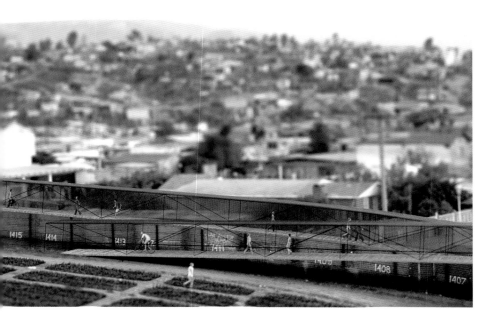

13. Social infrastructure in the form of bicycle and pedestrian paths builds off the wall's existing massive steel armature.

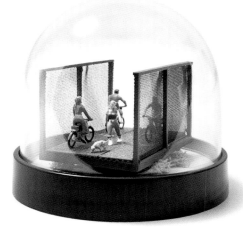

14. There is good reason to believe that the wall can serve as a linear urban corridor through border cities that it divides.

15. A pedestrian and bicycle path built into the wall allows people to be better connected to their respective cities.

15

Shoes

Both traveling to the wall and then getting up and over or under requires the right equipment. Immigrants may walk hundreds of miles in hot, arid, rocky, and harsh conditions before arriving at the wall. During the journey, their shoes often wear out, causing blisters, twisted ankles, and other foot injuries. One common technique to increase the longevity of worn-out shoes and protect the foot is to stuff them with leaves from the yucca plant. Not surprisingly, Native Americans in the border region have been fashioning shoes from yucca fiber for centuries.

Argentine artist Judi Werthein arrived at another solution. Perhaps in anticipation, the year before the Secure Fence Act of 2006 was passed Werthein designed shoes specifically for migrants intending to journey through the desert and traverse the wall. These cross-trainers are called Brinco, the word used by immigrants for their "jump" over the wall to the other side. A compass and a flashlight are attached to the shoelaces, as most immigrants attempt to cross at night. The shoes have a small pocket for hiding money from *coyotes* and also include Tylenol to alleviate the pain from injuries sustained on the journey. Printed on the removable insole is a map of the border showing the most popular routes from Tijuana to San Diego.

16. Brinco shoes by artist Judi Werthein are designed for a journey across the border.

The sneakers are high-tops to protect the ankles from twisting either on rocks or when descending the tall borderwall. Added protection comes from Santo Toribio Romo González, the patron saint of Mexican immigrants, whose image adorns the back ankle.[21] The heel of the shoe shows an abstraction of the Mexican golden eagle, while the toe bears that of the U.S. bald eagle, elegantly symbolizing the places the wearer is leaving behind and heading toward.

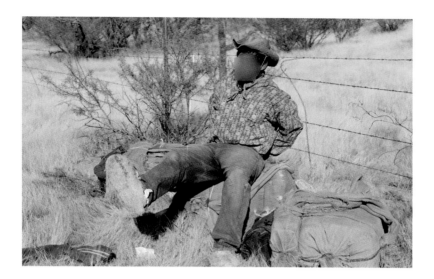

Embroidered on the shoes is the statement "This product was manufactured in China under a minimum wage of $42 a month working 12-hour days," underscoring the message of global trade inequity that the shoes, as an art piece, were designed to convey. One thousand pairs of the shoes were commissioned by inSITE San Diego, where Werthein exhibited them, as well as placed for sale in a hip San Diego boutique for $215 a pair. On the other side of the wall, Werthein distributed the shoes at a migrant shelter in Tijuana for free.

17. Smugglers wear shoes fashioned from pieces of shag carpet to conceal their footprints and avoid detection by Border Patrol agents.

In the small town of Sasabe, Sonora, another shoe design has emerged to aid in border crossing. For about $4 per shoe, customers can have the soles of their shoes covered with shag carpet or felt so that they will leave no footprints, making detection by Border Patrol agents more difficult. In the same vein, some border crossers glue large pieces of foam to the soles of their shoes. Both smugglers and immigrants disguise their soles, a useful tactic in landscapes that have been artificially smoothed by Border Patrol agents dragging tires to make footprints more visible.

Tire Dragging

As they do in many sites adjacent to the borderwall, Border Patrol agents near the town of San Luis, Arizona, practice what is known as "pulling the drag" or "cutting," both terms for traditional methods of hunting by cutting across a trail and sweeping back and forth along the expected direction in order to pick up tracks a considerable distance ahead.

Border Patrol agents, however, enhance this tactic by chaining together several tires (sometimes as many as eight), weighing them down with heavy steel bars, and then dragging them by a chain behind a Border Patrol SUV. By doing so, the agents pulverize the ground and sweep it smooth, erasing all disturbances in the zone near the fence and allowing new footprints to be clearly visible to agents. This practice is repeated throughout the day and again often at dusk, so that new tracks will be revealed in the morning, highlighted by long shadows cast by the rising southwestern sun.

Conceptually, these manicured landscapes are remarkably similar to the raked gravel in traditional Zen gardens. These

18. A U.S. Border Patrol vehicle pulls tires through the fragile desert landscape along the borderwall to assist in the detection of footprints of migrants crossing the border.

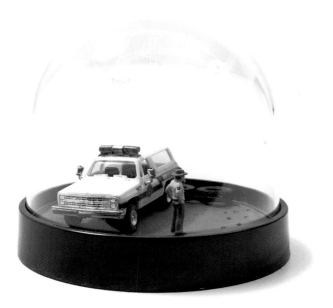

petrified landscapes remain suspended in time until the next intruder interrupts the serenity of the tabula rasa formed by the grooming, which creates clouds of dust in long rows that mirror the wall from a distance—an ephemeral wall made of particles that disappear back into the landscape.

But as useful as these Zen gardens are to the U.S. Border Patrol, there is little actual tranquility achieved by the constant raking. The fragile desert soils cannot easily recover from the compaction caused by the heavy traffic along the wall, and the damage to both the soil and the vegetation leads to erosion and drainage problems. The Washington-based group Defenders of Wildlife is also concerned about the effects of tire dragging for the rare Sonoran pronghorn, because the practice both degrades vegetation and disturbs the animals. Some ecologists have also found that the practice crushes lizards sunbathing in the wide swaths of these Border Patrol superhighways.[22]

19. A U.S. Border Patrol agent examines footprints in the ground smoothed by "pulling the drag."

Organ Pipe Cactus National Monument

Organ Pipe Cactus National Monument was established in 1937 to preserve approximately 330,000 acres of the Sonoran Desert, and in 1976 the monument was declared an International Biosphere Reserve by the United Nations. In 1978, Congress designated nearly 95 percent of all monument lands as wilderness, which "generally prohibits the use of motor vehicles except through special provisions for motor vehicle use when required in emergencies or as necessary for the administration of an area."[23]

But because of the provisions set forth by the Secure Fence Act of 2006, which usurps preexisting protections afforded the monument by the Wilderness Act, there are today an estimated 2,553 miles of unauthorized roads and trails through the monument. A majority (96 percent) of the all-terrain-vehicle tracks cutting between established roads are made by U.S. Border Patrol agents, who are required to stay on designated roads except in the case of "exigent circumstances."[24]

The border defining the southern edge of the monument is a highway of dust, devoid of the rich ecological fabric the park was intended to preserve, that follows the path of the $18-million, 23-mile-long vehicular wall. These roads, both the designated and the unauthorized, cause erosion and damage the fragile ecosystem's vegetation, wildlife habitat, and native soil. Ironically, due to the construction of the vehicular wall in 2006, which was meant to halt unauthorized traffic through the park, the number of both vehicle tracks and pedestrian foot trails has increased.[25]

20. Unauthorized roads and trails at Organ Pipe Cactus National Monument in 2010. Drawing adapted from map by the National Park Service.

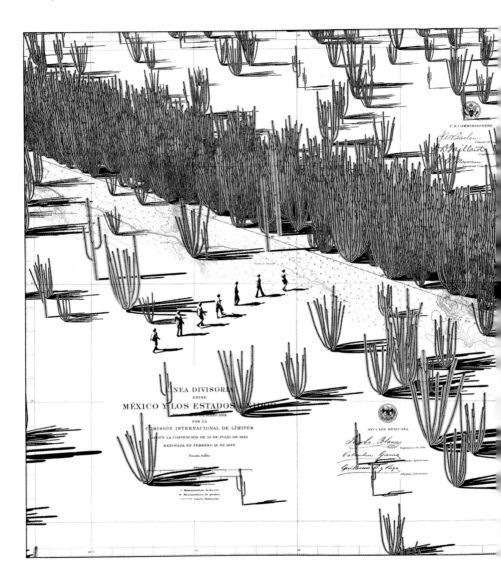

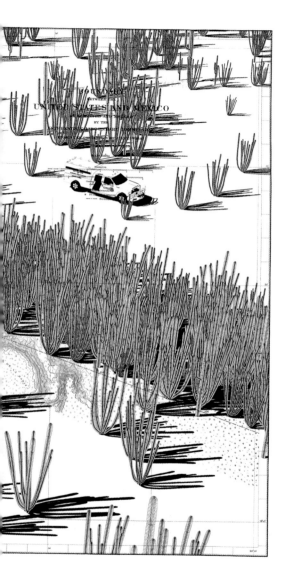

Cactus Wall

Perhaps a better solution than maintaining a wall of steel at the border in Organ Pipe Cactus National Monument would be to redirect those funds and invest in an infrastructure of planting and mitigation of the natural ecology. A natural obstacle—which Homeland Security considers an effective barrier—could be created through the intensive reintroduction of indigenous plants along the borderwall and in areas where undesignated roads have been created by off-roading Border Patrol agents and smugglers.

A new infrastructure of prickly succulents—a Cactus Wall—would be created both along the wall and throughout the monument. While the intentionality of the plantings might at first seem to be at odds with the wilderness designation of the park, it is still a far more natural and sustainable option than the destruction of the fragile ecosystem of Organ Pipe Cactus National Monument.

21. Replacing the steel wall with a Cactus Wall could help to re-introduce native plants to a fragile ecology denuded by vehicles in Organ Pipe Cactus National Monument.

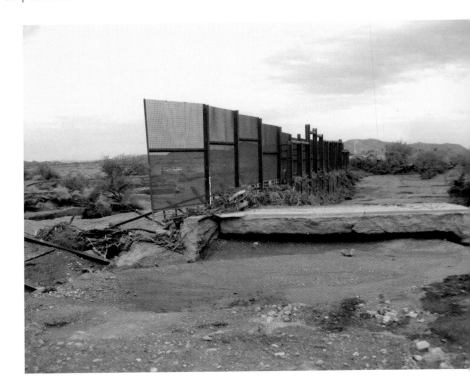

Dam Wall

Although the wall constructed in Organ Pipe Cactus National Monument does not seem to be stopping traffic, it does appear to be well suited to stopping water. In 2008, a 5-mile-long pedestrian wall was constructed in the park. It crosses several arroyos along its route, but the designers of the wall did not consider how to allow water from seasonal rains to flow freely through the wall. The same year the wall was constructed, a 2.5-inch rain fell in the park, causing debris—mostly grass, leaves, and limbs—to wash against the 15-foot-tall wire mesh pedestrian wall and plug the holes in the metal grate. This transformed the wall into a dam, causing the upstream water levels to rise as much as 7 feet and push more debris against the wall.

22. Isolated, intense rainstorms destroyed the pedestrian wall at Organ Pipe Cactus National Monument.

Unable to drain properly, because a 6-foot-deep foundation blocked subsurface drainage, the water found alternate routes parallel to the wall (quickly eroding the roads denuded of vegetation by Border Patrol vehicles) and rushed toward the border towns of Lukeville and Sonoyta, flooding their port-of-entry stations and damaging several buildings and the wall itself. A similar flood occurred again in 2010 in Organ Pipe Cactus National Monument, but this time, in addition to flooding the nearby ports of entry, the wall itself collapsed, and 40 feet of the $23.3-million wall was washed away.[26]

In other areas along the border, the wall is also an effective, if accidental, water-collection system. In 2008, rainstorms caused debris to build up against the wall, sending enormous amounts of water into the cities of Nogales, Arizona, and Heroica Nogales, Sonora, causing disastrous flooding. The flooding of the sister cities drowned two people and inundated several hundred businesses and homes with up to 5 feet of water, causing many vehicles to float away.

Once again, in July 2014, heavy rains washed debris into the wall dividing Nogales and Heroica Nogales. This time 60 feet of the gargantuan, 18- to 26-foot-tall borderwall (with 7-foot-deep foundations) collapsed, and several homes were damaged after the rush of water had overwhelmed lower-income neighborhoods downstream.

23. Sketch of Aqueduct Wall, which captures and transfers water for a wide range of uses.

AQUEDUCT WALL

Hydro Wall

Water collection, when considered proactively rather than as an afterthought, can be a transformative system for the desert communities along the border. For example, the city of El Paso levies storm-water fees on all landowners based on the amount of their property's impervious surfaces and plans to raise $650 million for a system of storm-water catchments to ameliorate the effects of flooding.

El Paso is divided from Ciudad Juárez by a large concrete basin where the Rio Grande/Rio Bravo once flowed. By introducing catchments along the basin, a linear park and riparian ecology could be created, and water could once again flow through the two cities. Additional rainwater-collection shed roofs along the existing wall would increase the amount of water collected and create cool, well-shaded places where performances, markets, and other events could take place.

The creation of a linear water park in the space where the Rio Grande/Rio Bravo once flowed also has security implications. The purpose of wall construction is not to stop the flow of immigrants from the south, but rather to slow it down. According to the Department of Homeland Security, the wall gives Border Patrol agents a few more minutes to stop illegal crossings.[27] The department also sees rivers as natural obstacles yielding an additional five minutes to the Border Patrol. Creating a linear water park that meanders on both sides of the border by reintroducing water into the existing basin along the wall would create a secure, tactical, social, ecological, and hydrological infrastructure.

24

25

26

24. Plan of Hydro Wall demonstrating a binational riparian park between El Paso and Ciudad Juárez.

25. Cross section of Hydro Wall showing paths and shaded areas in the binational river park.

26. Cross section of the river park.

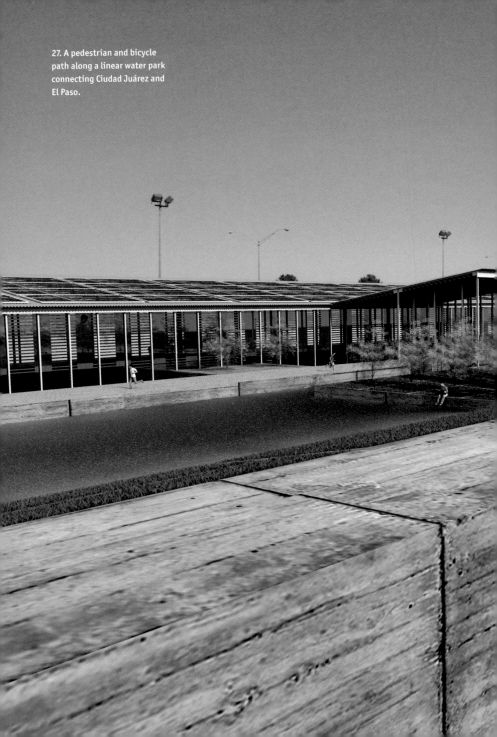

27. A pedestrian and bicycle path along a linear water park connecting Ciudad Juárez and El Paso.

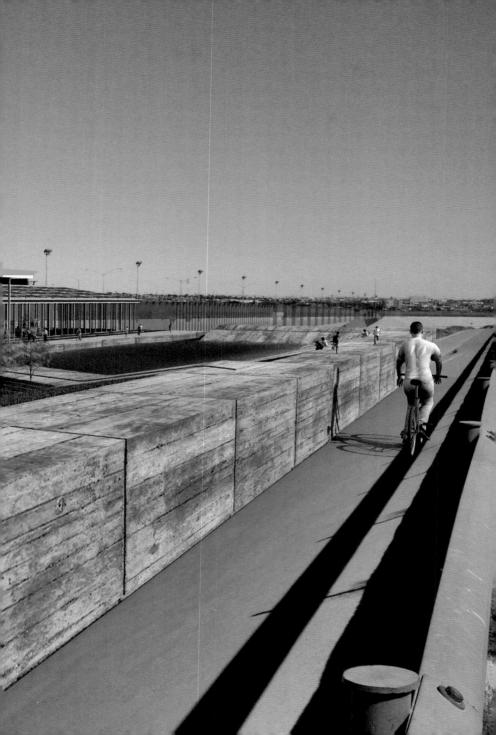

Fog Wall

Fog is a problem for Border Patrol agents, especially along the stretch of wall that dives into the humid Pacific coast near Tijuana. It decreases visibility through surveillance cameras and binoculars and creates opportunities for people attempting to cross or dismantle the wall. While it would be difficult to create a barrier that could actually prevent fog from migrating inland, a different kind of wall could be attached to the existing wall to capture fog and convert it to clean, drinkable water. Many communities in Tijuana do not have access to potable water and are at risk for waterborne illness and disease. The existing overstructured borderwall could be the armature for a lightweight water harvesting and delivery system.

28. A fog-capturing infrastructure transforms the borderwall into a clean-water delivery system.

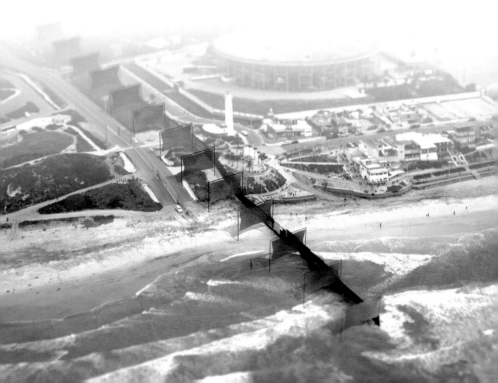

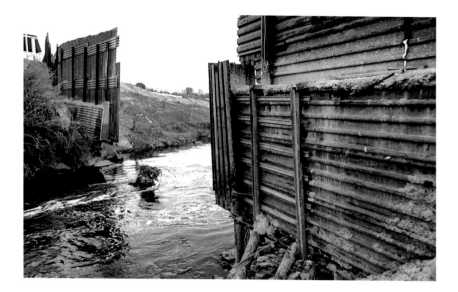

New River

The New River is considered the most polluted river in the United States.[28] It flows north from Mexicali and crosses the border at Calexico. The New River's toxicity is composed of chemical runoff; tuberculosis, hepatitis, cholera, and other pathogens; and fecal coliform bacteria, which at the border checkpoint far exceeds U.S.-Mexico treaty limits.

At the point where the river reaches the border, the wall—which is designed to delay the flow of humans—opens to allow the polluted water to enter freely. The New River then flows through the Imperial Valley, known as America's winter salad bowl, which is a major source of vegetables, fruits, and grains. Although, according to President George W. Bush, the Secure Fence Act of 2006 was enacted to "help protect the American people" from illegal immigration, drug smuggling, and terrorism,[29] the New River represents a far more dangerous flow north from Mexico in need of containment.

29. The wall opens to allow the extremely polluted New River to enter the United States from Mexico.

Wastewater Treatment Wall

A Wastewater Treatment Wall located in the 2-mile-long wasteland between Mexicali and the Imperial Valley is one possible solution to the illegal migration of toxins into the United States—a problem that is expected to worsen as the Mexicali Valley's population, already at 1.3 million,[30] continues to expand without adequate infrastructure.

For $33 million, the same cost as the wall dividing Calexico and Mexicali, it would be possible to construct a wastewater treatment facility that could handle 20 million gallons of effluent per day from the New River. This proposed facility is composed of a linear pond filtration and purification system, which would create a secure border infrastructure. The by-products of the wastewater treatment facility would include methane, which can power streetlights, and irrigation water—a combination capable of supporting a series of illuminated green corridors that could in turn contribute to a healthy social infrastructure linking these growing border cities.

30. Cross section of proposed Wastewater Treatment Wall section.

31. Aerial view of proposed wastewater treatment plant serving Calexico, California, and Mexicali, Baja California.

30

31

Chamizal National Memorial

Between 889 and 1,248 miles of the U.S.-Mexico border is defined by the Rio Grande/Rio Bravo del Norte. The variable length is a function of the river, which is a geologic entity in constant flux. Defining the political border with the river has proved problematic at times. It was the cause of a hundred-year border dispute between the United States and Mexico in which, it is often said, "not one shot was fired; not one war was waged." That dispute is now memorialized in a peace park called the Chamizal National Memorial. So what was the hundred-year argument about?

The 1848 Treaty of Guadalupe Hidalgo, which signaled the official end to the Mexican-American War, specified a new boundary between the two countries. Much of that new border was defined as the center of the river, regardless of alterations of the river's channel or banks, provided that such transformations were the result of gradual, natural causes. According to the treaty, if the river changes course, as rivers do, because of deposits of clay, silt, sand, or gravel, the political border changes with this shift. However, if the river changes course due to a sudden avulsion, then the previous course of the river continues to define the border.

In the years following the signing of the Treaty of Guadalupe Hidalgo, the stretch of the Rio Grande/Rio Bravo that separated the cities of El Paso and Ciudad Juárez began to shift southward, with a major shift due to flooding in 1864. By 1873, approximately 600 acres of land that had been south of the Rio Grande in 1848 were now north of the river, effectively making the land the property of the United States, and it was incorporated into the City of El Paso. In 1895 a suit was filed in the Juárez Primary Court of Claims by the once-owner of the land.

Mexico and the United States agreed in 1910 for the dispute to be settled by the International Boundary Commission, which had been created in 1889 to determine if changes in the river's course had been gradual, if the Treaty of 1884 applied, and if boundaries set by the treaties were binding.[31]

32. Diagram of historical flow of Rio Grande/Rio Bravo.

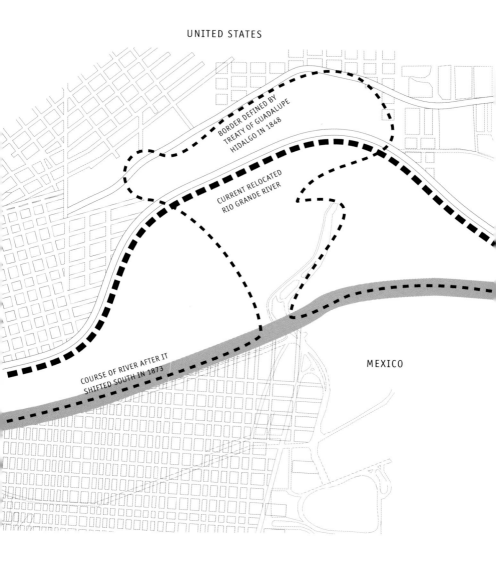

UNITED STATES

BORDER DEFINED BY
TREATY OF GUADALUPE
HIDALGO IN 1848

CURRENT RELOCATED
RIO GRANDE RIVER

COURSE OF RIVER AFTER IT
SHIFTED SOUTH IN 1873

MEXICO

In the case of the disappearing land of Pedro I. García, Mexico claimed that the boundary itself had never changed, only the river, and therefore the land was Mexican territory. The United States argued that the boundary was a result of gradual erosion, and therefore the 1884 treaty applied, making it U.S. soil.

The commission recommended that a portion of the land between the 1852 riverbed and the 1864 river would become U.S. territory and the remainder of the land would become Mexican territory. The United States rejected this proposal, and during the ensuing years of deadlock, a parcel of land in the middle of the river called Isla de Córdoba, or Cordova Island—belonging to Mexico but inside U.S. territory—became a kind of free zone, unpoliced by authorities from either side. Cordova Island thus became a haven for criminal activity and illegal border crossings and the home of an infamous drinking and gambling house appropriately named the Hole in the Wall Saloon.

33. President Lyndon B. Johnson shakes hands with President Adolfo López Mateos of Mexico at the new boundary marker.

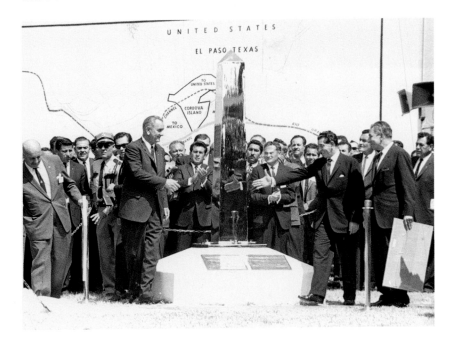

Many more attempts were made to resolve the debate between 1910 and 1963, but finally on January 14, 1963, President John F. Kennedy's administration agreed to settle the dispute based on a 1911 arbitration award. A year later, Mexico was awarded 366 acres of the Chamizal area, as well as 71 acres east of Cordova Island. American families, many of Mexican heritage but U.S. citizenship, who had settled in the disputed land had to move from Cordova Island, leaving behind abandoned homes and businesses. The United States was awarded 193 acres of Cordova Island and people were compensated for 382 structures; thus, 382 American works of architecture and building were absorbed by Mexico. To make the separation clear, both nations agreed to reroute the Rio Grande/Rio Bravo in a concrete channel and to share the costs. The American-Mexican Chamizal Convention Act of 1964 formally settled the dispute, and in September 1964, Presidents Lyndon B. Johnson and Adolfo López Mateos met and shook hands across the divide.

Avulsion Wall

The fluctuations of the river and the subsequent fluctuations of the political border could be used as a strategy for urban planning. Rather than attempting to stop the natural avulsions of the river by forcing it through concrete canals, allowing the river to meander within its riparian floodplain could create organic possibilities for urban development as well as immigration reform, with residents gaining citizenship from the river itself as it takes its natural course. Greenbelts, or hundred-year-flood parks, would correspond to areas where the river once flowed, and planning for new neighborhoods, with architectural styles that respond to cultural shifts, would be determined by the natural avulsions of the river.

(OVERLEAF)
34. If shifting rivers were strategies for urban planning, a third city, a city planned by the fluctuating river, might develop between the two sister cities of Brownsville, Texas, and Matamoros, Tamaulipas, at the border.

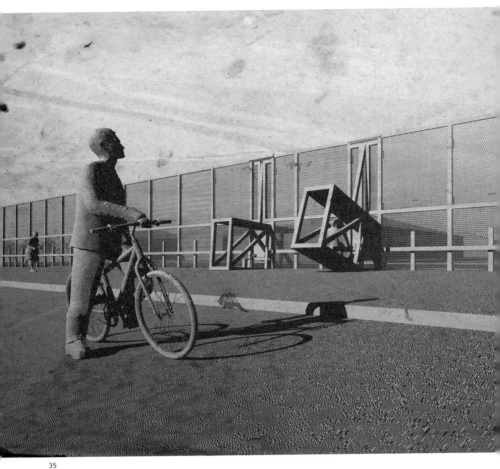

35

36

Swing Wall

The Rio Grande/Rio Bravo naturally honors no boundary. It perpetually shifts back and forth across the border, even as it defines the border. What if the borderwall similarly allowed one to move back and forth across the wall, while still being constrained by the definition of a boundary? A Swing Wall would exemplify the incongruity of a boundary constantly in flux—the river—and the fortification of that boundary with the fixed architecture of the wall. People could board the double-sided swing from either side and swing such that their bodies would physically cross to the other side, with no way to actually exit, before returning back to their country of origin.

35. Swinging from nation to nation in a binational park.

36. Swing Wall section.

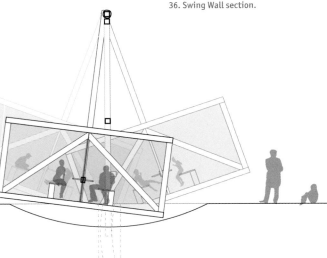

Friendship Park

On Monument Mesa in Border Field State Park, along the
U.S.-Mexico border in San Diego County, stands a small site
where the U.S.-Mexico Boundary Commission met in 1849 and
placed a monument to mark the new international boundary.
The site has taken on various permutations since then, due to
the increased militarization of the border. In 1849, crossings
in the area were unregulated, but by 1924, when the United
States Border Patrol was created, infrastructure was put into
place to secure the border. After World War II, the interna-
tional boundary at the site of the monument was marked with
barbed wire.

In 1971, the surrounding 800 acres were inaugurated by
First Lady Pat Nixon as Border Field State Park, with the area
around the monument designated as Friendship Park, a place
where people from both nations could gather to visit with
family and friends to share goodwill across the line. During
the ceremony, Mrs. Nixon, in an effort to demonstrate the
power of friendship, instructed her security detail to remove
the barbed wire fence so she could better greet the crowd.

37. First Lady Pat Nixon shakes
hands through the barbed wire
fence at Friendship Park in 1971.

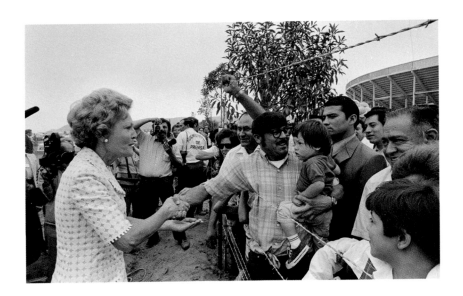

Despite Mrs. Nixon's demonstration of goodwill, by the 1990s the border was further fortified by a large wall built from recycled Vietnam War–era landing mats and steel wire. But despite the erection of the fence, Friendship Park remained a popular destination due to its beautiful vistas, its historical monument, and its public beach.

In fact, in many ways, the wall brought people together, with many shared activities taking place there (many of which inspired this book)—from yoga (see "Yoga Wall") and volleyball (see "Wall y Ball") to picnics and religious services (see "Communion Wall" and "Confessional Wall")—all shared by participants from both sides of the wall.

38. Steel wire pokes the arm of a family member caressing an infant through the wall at Friendship Park.

Despite the law's name, the Secure Fence Act of 2006 was the catalyst for a structure much more exemplary of a wall than the previous fence-like structure. In 2007, an 18-foot-high wall was constructed to replace the previous barrier. This was followed in 2009 by the construction of a secondary wall 90 feet away from the first wall to create a "security zone," consigning Friendship Park to the space between the two walls and closing the park.

While the Mexican side of Friendship Park is still accessible twenty-four hours a day, seven days a week, the U.S. Border Patrol, after much negotiation with the community, currently allows only twenty-five people at a time on Saturdays and Sundays between 10:00 A.M. and 2:00 P.M. to enter this "Friendship Park."

What might Pat Nixon think of her "place of goodwill" now? While shaking hands with the residents of Tijuana through the thin strands of barbed wire in 1971, she commented, "I hate to see a fence anywhere," and as she walked across the border to embrace the Mexican children, she said, "I hope there won't be a fence here too much longer."[32]

Yoga Wall

Group activities have been shown to both create social capital and serve as a way to cope with the realities of the wall. In 2008, the Border Meetup Group, coordinated by Dan Watman, began arranging social events that promoted "cross-border understanding" in Friendship Park. One of these events was a binational yoga class in which mats were laid out on both sides of the wall for meditation and stretching across the border.

The word *yoga* comes from Sanskrit and means "uniting," and the goal of the practice is *moksha*, or "liberation." Thus, such classes can bring people together in the name of unity and freedom, and they can become "one" through the wall.

39. Binational yoga class of the Border Meetup Group at Friendship Park.

Wall y Ball

William G. Morgan invented the game of volleyball, or "mintonette" as it was originally called, in 1895. Morgan had observed that basketball, a sport introduced just four years earlier by his college classmate James Naismith, was much too demanding a sport for many people, and he wanted to create a sport in which everyone had an equal opportunity to participate—a sport that anyone could play.

A little over a century after the invention of this sport of equality, volleyball would serve as an agent for demonstrating the similarities and relationships between both sides of the borderwall. In 2006, Brent Hoff, then editor of the DVD magazine *Wholphin*, published by McSweeney's, staged what he imagined to be the world's first game of international-border volleyball.

Hoff's premise raised some interesting questions: Is such a game legal? Does throwing a ball back and forth over the border constitute illegal trade? Hoff's version of the game was much more physical than traditional volleyball because spiking the ball was impossible, and powerful hits were required to send the ball arching up to 50 feet into the air and over the wall, causing bruises to the wrists and arms of the players.[33]

40. Residents of Naco, Arizona, and Naco, Sonora, play volleyball during the Fiesta Binacional in 2007.

In addition to causing a stir in the international media, the simple game of beach volleyball over the borderwall achieved something remarkable: more than an act of political theater, the game conceptually dismantled the meaning of the wall. By dematerializing the two-story metal posts from an insurmountable obstacle into nothing more than a line in the sand, and with the players on each side keenly aware of the players on the other, the wall became nothing more than a rule to be negotiated by the minds, bodies, and spirits of the players.

This conceptually transformed game in many ways mirrored the ritualistic game of *ulama*, a ball game still played by a few communities in Mexico and one of the oldest continuously played sports in the world (as well as the oldest-known sport using a rubber ball). Ulama could be described as a wall-less volleyball game in which players on each side attempt to keep a heavy rubber ball in the air and pass it over a line drawn in the sand, using only their hips.

Despite there being no barrier between the two sides, it is a rough physical game, and the hard ball propelled by the hips of the players has been known to cause grave injury and even death. Both Morgan's volleyball and ulama speak to relationships between people on the two sides of a border, whether demarcated by an imaginary line or a wall. Pain and suffering, equality, friendship, competition, and the desire to transcend barriers are all present both in the rules of the games and in the daily lives of those who engage the wall on a daily basis.

41. Aztec ballplayers performing for Charles V in Madrid in 1528.

42. A Border Patrol agent and a referee police a game of Wall y Ball.

Just as William G. Morgan was probably not familiar with ulama when he invented volleyball, Brent Hoff did not know that his was not the first game of international-border volleyball ever played. In 1979, twenty-seven years before Hoff took to the beach in Friendship Park to serve it up against

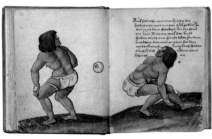

41

players on the other side, a humble game of volleyball was played between the citizens of Naco, Arizona, and Naco,

Sonora. It was part of the first Fiesta Binacional, a celebration focused on defying the physical divisions imposed upon the residents of the sister cities and the larger region.[34]

In addition to booths, food, picnic tables, and various events set up on each side of the wall—as well as a Tecate stand that somehow was permitted to straddle the border[35]—a volleyball court was created on both sides of the 13-foot-high wall. It is here that the United States and Mexico first came together to play a sport whose historical origins had developed independently in each of their respective countries. Since then, the game has been played many times at the Fiestas Binacionales, but who won that first game of "wall y ball"?

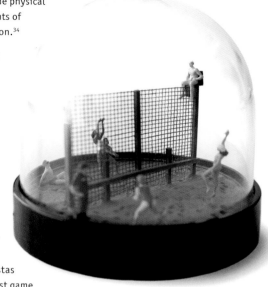

42

Despite the U.S. side having the advantage, the wall's barbed wire top was tilted toward the Mexican side, and the match resulted in a win for Mexico. Although symbolic barriers were dismantled during that first Fiesta Binacional game, the wall-cum-net dividing the two teams allowed only three fingers of a "good-game" handshake of friendship at the conclusion of the game—they were all that could fit through the metal grate.[36]

The same year that the first borderwall game of volleyball was played in the two Nacos, Bill Dejonghe of Calabasas, California, invented a game he officially named wallyball, a fast-paced version of volleyball played in a racquetball court. According to the American Wallyball Association, it is now played by over 15 million people around the world. And just as in the ancient game of ulama, which was being played by A.D. 800 in what is now both the United States and Mexico, the ball used in wallyball must be made of rubber.

Communion Wall

In 2014, a group of Catholic bishops from as far away as
Georgia and Guatemala gathered at the wall in Nogales,
Arizona, both to celebrate a Mass in remembrance of immi-
grants who died attempting to cross the border and to show
their support for immigration reform. People on both sides
of the border attended the bilingual Mass, and the bishops
offered those on the Mexican side of the wall Communion, a
ritual uniting Christians with
each other and with Jesus
Christ by sharing sacramental
bread and wine. The bishops
reached through the rusty
wall to offer the bread to the
attendees.

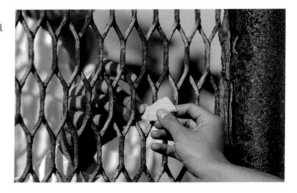

This was not the first time
Communion had been
delivered through the wall.
Every Sunday since 2008,
Communion has been given
through the fence by John
Fanestil, an ordained elder
in the United Methodist Church and the executive director of
the San Diego Foundation for Change at the Border Church
located in Friendship Park. The ritual of Communion has
increasingly been seen as an act of civil disobedience. In
2009, Border Patrol agents forcibly removed Fanestil from the
area to prevent him from performing the rite. Despite this
setback, Fanestil resumed the practice from 1:00 P.M. to 2:00
P.M. each Sunday.

43. A piece of tortilla is shared
through the wall during a "World
Communion" celebration in
Tijuana, Mexico, in 2008.

Confessional Wall

Additional spiritual practices are possible at the wall. A
double-sided, perforated wall designed with a cruciform plan
to enable private conversations would allow the wall to serve
as a place for confession. If the compartments required for

privacy in this rite were oriented perpendicular to the border, with the wall itself acting as the screen, additional confessions might be required of confessor and priest, both of whom would need to ask forgiveness for the literal trespasses each had made by crossing the border—technically illegally—in order to enter the confessional to perform the sacred rite.

44. Confessional Wall sketch.

45. The Confessional Wall offers an opportunity for people to cross the political border on one side, and a priest on the other, while the confessional keeps them bound to their respective countries, in order to confess their sins.

44

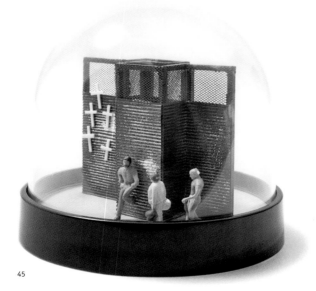

45

(OVERLEAF)
46. Confessors wait their turn to confess their "transgressions."

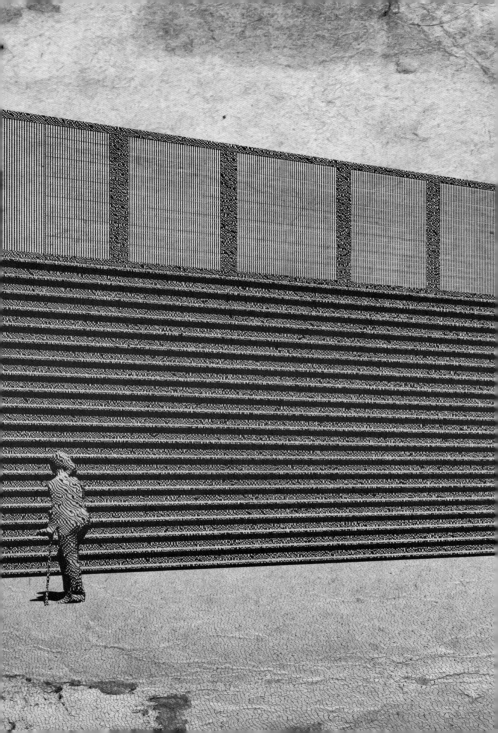

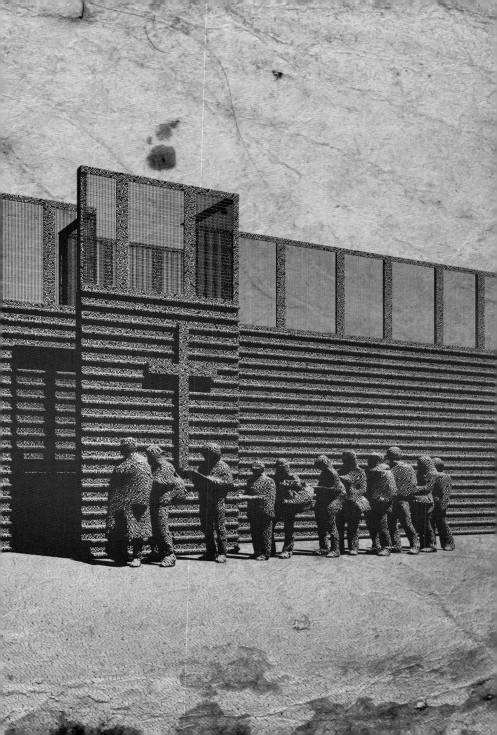

Whispering Wall

If the whispers of confession can transcend the wall, perhaps other means of communication can as well. For several years border poet and activist Daniel Watman has organized cross-border poetry readings through the porous wall dividing Tijuana and San Diego. After the expansion of the single wall to a triple wall that separated people on either side of a 150-foot no-man's-land, the readings became even more creative.

Giant sound disks were constructed on either side of the walls, reminiscent of the concrete acoustic "mirrors" used to amplify the sound of incoming enemy aircraft engines in Great Britain during World War II. In this case, however, language was the weapon wielded to combat the divisiveness of the wall through this forum for creativity. These giant ears, or "whispering dishes," constructed of tape and fabric allowed for conversations across the great divide.

Perhaps even more profound than these whispers was the silent language communicated across the distance between the walls as the deaf communities in Mexico and the United States came together to read poetry and have discussions across the barrier. Using binoculars and sign language— translating from English to American sign language to Mexican sign language to Spanish and back again—they conceptually crossed not only a physical barrier but several language barriers as well.[37]

Watman saw that the deaf community in Tijuana lives on the fringes of society, and through his events, he surmounted the barriers of two cultures, three walls, and four languages.

Xylophobia

In one episode of the animated series *The Simpsons*, the residents of Springfield construct a wall around their town so that residents of the neighboring town do not come in and take jobs away from them. In the episode, Homer Simpson attempts to find commonalities with his daughter, Lisa, telling her, "I share your xylophobia," to which Lisa replies, "No, Dad, you mean *xenophobia*. *Xylophobia* would be the fear of xylophones." Homer retorts, "I *am* afraid of xylophones—it's the music you hear when skeletons are dancing!"[38]

Homer's fear of his neighbors is as unreasonable as his fear of xylophones. Rather than constructing walls along the border as a manifestation of the irrational fear of that which is foreign, perhaps it would be more reasonable to construct xylophones along the border. In fact, what if the wall itself were the world's largest xylophone, played by thousands of people across the two countries?

A Xylophone Wall would allow for planned and impromptu binational group performances, bringing people together from both sides of the border to create a singular sonic experience that would conceptually transform the space of the existing wall into a performance.

47. A Border Patrol agent accompanies musician Glenn Weyant in an ad hoc performance using "implements of mass percussion."

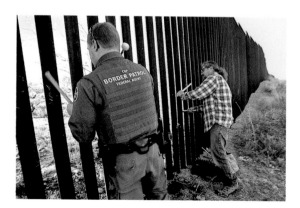

(OVERLEAF)
48. A Xylophone Wall allows for binational performances on the border. Concept drawing on original plat of U.S.-Mexico border.

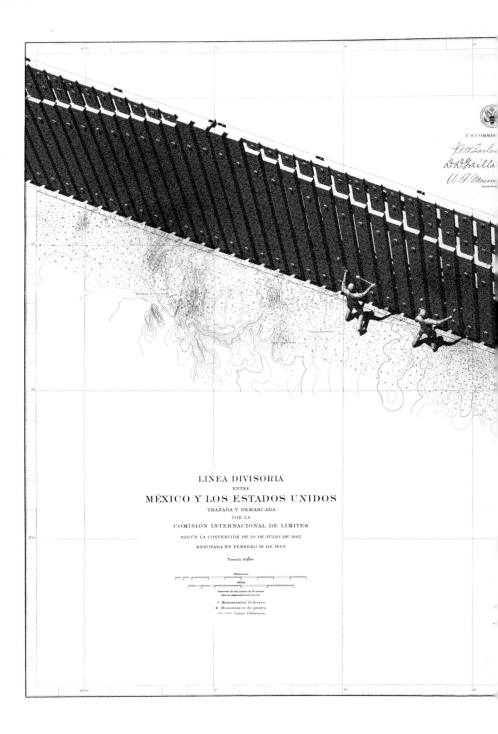

LÍNEA DIVISORIA

ENTRE

MÉXICO Y LOS ESTADOS UNIDOS

TRAZADA Y DEMARCADA

POR LA

COMISIÓN INTERNACIONAL DE LÍMITES

SEGÚN LA CONVENCIÓN DE 29 DE JULIO DE 1882

RENOVADA EN FEBRERO 18 DE 1889

Escala 6/50.000

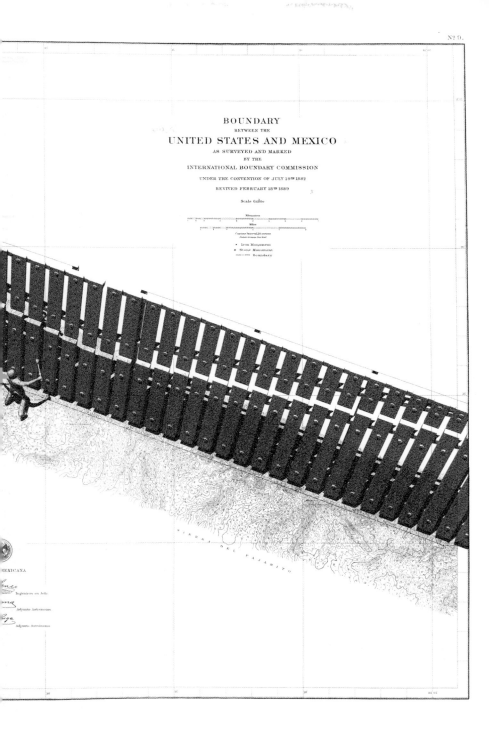

BOUNDARY
BETWEEN THE
UNITED STATES AND MEXICO
AS SURVEYED AND MARKED
BY THE
INTERNATIONAL BOUNDARY COMMISSION
UNDER THE CONVENTION OF JULY 29TH 1882
REVIVED FEBRUARY 18TH 1889

Scale 60000

• Iron Monument
▪ Stone Monument
———— Boundary

SIERRA DEL PAJARITO

Musician Glenn Weyant believes that such
an instrument has already been con-
structed, and he has accepted the
challenge of learning to play the
wall, thereby deconstructing its
meaning and transforming it into
"an instrument so that people
on both sides can have open
dialogue and communication."[39]
Instead of remaining merely an
implement of division, the wall
is transformed literally into an
instrument of creation with
the power to unite.[40]

Weyant plays the wall as
a percussion instrument,
using drumsticks, mallets,
and sticks he finds on the
ground—"implements of mass percus-
sion" he calls them, in reference to the weap-
ons of mass destruction that propagated further expansion
of the wall.[41] He also treats the wall as a string instrument,
rubbing violin and cello bows across the rusty steel to explore
a new frontier of sound as part of his SonicAnta project (*anta*
is a Sanskrit word for "border" or "end of known territory").

Weyant's performances have been monitored and inspected
by armed agents of the U.S. Border Patrol, the Department
of Homeland Security, and the City of Nogales Police
Department. Border Patrol agents have also been both
passive and active participants in his performances, either
by being unwittingly recorded by him on their approach to
question his actions or by accepting his invitation to pound
on the fence with him to explore what he describes as "an
ever-changing borderland sound ecology."

49. A souvenir of the Xylophone
Wall.

Tortilla Wall

The Tortilla Wall—El Muro de la Tortilla (or La Cerca de la
Tortilla), as it is called in Mexico—is the 14-mile section of
borderwall extending from Friendship Park to the Otay Mesa
border crossing. It is one of the oldest sections of large-scale
wall construction and was completed in 1990.

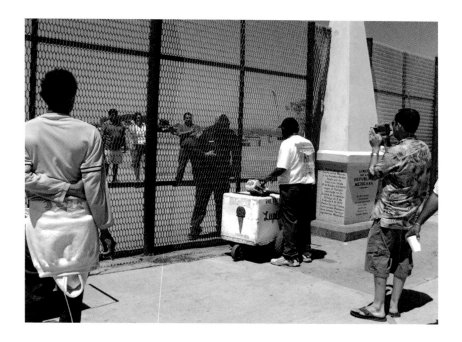

50. A Border Patrol agent pur-
chases a *paleta*, a frozen treat,
through the wall from a vendor
in Mexico.

51

BURRITO WALL

Burrito Wall

Casual exchanges are common across the borderwall, ranging from small talk, long visits with family and friends, and commercial transactions of items ranging from food and jewelry to contraband. Even Border Patrol agents occasionally participate in this commerce, illegality notwithstanding. Combining food culture with the wall itself could utilize a built-in infrastructure for food carts and seating on both sides of the wall so that food, conversation, and culture might be shared—under the shade of the security overhang—across nations.

51. Burrito Wall sketch.

52. Sharing a meal across a wall with built-in tables, chairs, and grill.

53. Burrito Wall section.

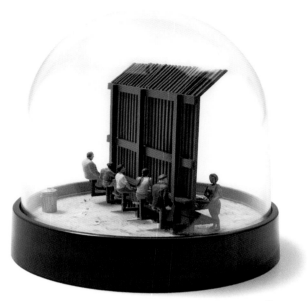

52

53

Library Wall

The Haskell Free Library and Opera House was built in 1904 directly on the U.S.-Canada border between the towns of Derby Line, Vermont, and Stanstead, Quebec. The placement was intentional on the part of the builders, American Carlos Haskell and his Canadian wife, Martha Stewart, so that the library's collection would be available to residents of both countries. The building is sometimes referred to as "the only library in the United States with no books," because the book stacks lie on the Canadian side. The international boundary is indicated by a thick black line running diagonally across the library's reading room floor.

What if this same gracious and generous ingenuity could be incorporated into the design and implementation of the U.S.-Mexico borderwall? A binational library straddling the two sister cities of Nogales would allow for transnational exchanges of books, ideas, and knowledge through a cross-border book exchange program. The borderwall could be transformed into a border-bookshelf, encouraging dialogue and cultural exchange through the wall itself.

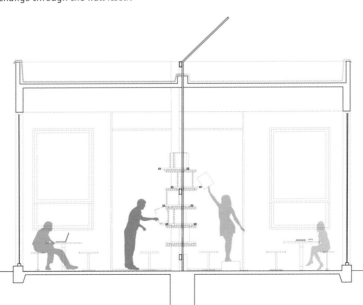

54

55

54. Interior perspective sketch of
the Binational Library.

55. The wall is transformed
into a bookshelf through which
knowledge and information can
be shared.

(OVERLEAF)
56. The proposed Ambos Nogales
Binational Library.

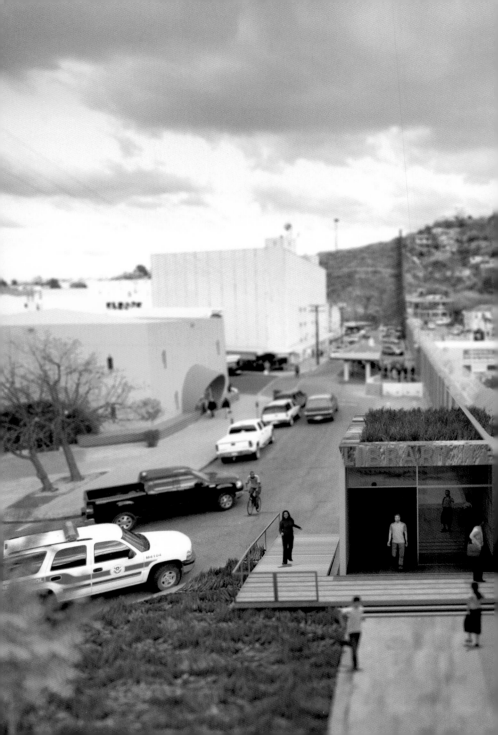

Theater Wall

The Opera House portion of the Haskell Building is sometimes called "the only opera house in the United States with no stage." The theater is divided in half, with the stage and half the seats in Canada and the remainder of the seats in the United States.

Taking this idea further, a Theater Wall on the U.S.-Mexico border could be constructed using a perpendicular strategy, creating an environment that subverts the traditional hierarchy between performer and stage. Binational performances could take place with talents performing on both sides of the wall, either separately or together. The audience would also play a role in the performance, as the tension created by the wall would serve to bring people together as they gazed at each other through the diaphanous screen dividing the space.

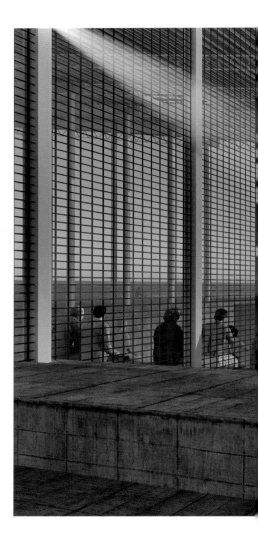

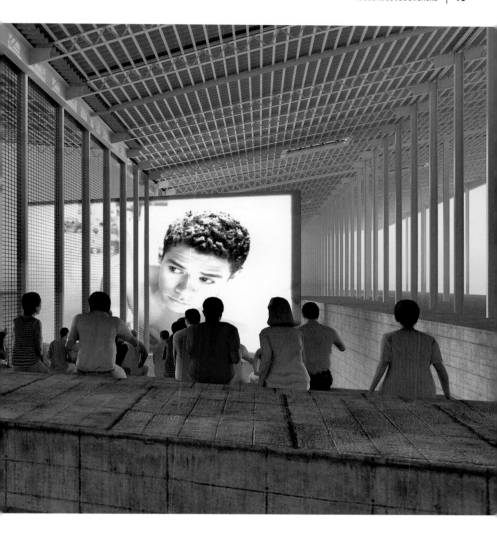

57. Theater and stage are divided
by the wall—blurring the bound-
aries between performer and
audience in a binational theater.

El Parque EcoAlberto

Another type of border theater takes place approximately 700
miles south of the U.S.-Mexico border in the state of Hidalgo.
The 3,000-acre Parque EcoAlberto, a large natural ecolog-
ical preserve managed by the indigenous HñaHñu people,
comprises rivers, canyons, wildlife, and other attractions.
Over the past several years, the HñaHñu have seen their
villages become ghost towns as members their community
have immigrated to the United States en masse. Hidalgo is
one of the top three Mexican states in terms of population
loss to the United States—as of 2012, the HñaHñu had lost 80
percent of their population to Arizona and Nevada.[42] Recently
they have seen their numbers dwindle to only a few hundred
permanent residents.

Members of the community—mainly youth who made the
harrowing journey north to the United States and returned
to tell about their experiences—arrived at an idea that would
bring income to the community while imparting a valuable
lesson to others considering making the journey north. In
addition to the tours, recreational zip lines, kayaking, hiking,
and rappelling that bring tourist dollars to their community,
the HñaHñu in 2005 began holding a nightly event that
simulates a border crossing, complete with faux *coyotes*[43]
(or might we say *fauxotes*?), Border Patrol agents, flashing
lights, dogs, gunshots, and fences to cross over. Of all the
attractions in Parque EcoAlberto, La Caminata Nocturna, or
"the Night Walk," is by far the most popular. For 200 pesos
(US$16) one can take an 11-mile journey through the park's
rough terrain and encounter many of the same obstacles that
immigrants do during their journeys north, of course, with-
out the physical, psychological, or emotional risks associated
with an actual journey.

Visitors can experience firsthand the suffering and risks they
might endure crossing the border, such as slipping through
barbed wire fences, negotiating steep, rocky hillsides,
traversing rivers, and encountering bandits. When partic-
ipants are discovered, "Border Patrol agents" shout with
perfect gringo accents, sirens blare, and gunshots are fired

(despite the fact that Border Patrol agents rarely use sirens or deploy firearms).[44] Being captured by agents, wrestled to the ground, and "deported back to Mexico" are all part of the experience, and the faux *mojados*[45] (or dare we say *fauxados*?) return dirty, tired, and with a few bumps and bruises.

The experience is also accompanied by a message from the hosts, which is that immigration is bad for local communities and local economies. Although critics of Parque EcoAlberto suggest that it is a training ground for migrants wishing to cross the border illegally, the theme park attracts mostly thrill seekers, middle-class Mexicans, and college-age students—all groups unlikely to attempt the actual journey north.

Fake Wall

In 1962, three prisoners incarcerated at Alcatraz Island attempted escape by digging through the concrete walls of their cells, disguising the holes with false walls made of painted cardboard. Similar ingenuity has been observed on the borderwall. In one location south of Yuma, Arizona, approximately 45 feet of the steel borderwall was destroyed with a blowtorch, and the metal posts that had been used as vehicle barriers were replaced with dummy posts made from painted cardboard, camouflaged to resemble the originals, fooling Border Patrol agents.[46] These tubes were easily removable, allowing them to be taken out of the way so vehicles could drive through.

Mock Walls

In 2011, students at the University of Arizona in Tucson erected a mock borderwall in the middle of their campus. The wall—approximately 1,000 feet long, 6 feet tall, and topped with barbed wire—was constructed to raise awareness among the campus community of the issues affecting the border regions in both the United States and the Middle East.[47]

The student activists dubbed the project *Wall to Wall—Concrete Connections/Conexiones Concretas* and installed it on the south lawn of the campus mall, blocking access to several buildings and forcing students to walk around the wall. The 50,000 students affected by the fence were forced to experience, albeit in a small way, the crisis caused by the border-wall. The wall, which was protected as an expression of free speech, divided the campus both figuratively and literally.

From April 20 to May 1, 2011, the University of Massachusetts Amherst campus was divided by a 1:1-scale photographic mural of the vehicle wall that defines the border in southern Arizona and also divides the Tohono O'odham Nation (see "Cemetery Wall"). The project was created by artist Catherine D'Ignazio and commissioned by the University Museum of Contemporary Art at UMass Amherst.[48]

In contrast, but also in 2011, students at Washington State University's Pullman campus, just 181 miles south of the U.S.-Canada border, also erected a mock borderwall on campus, but this time in protest of illegal immigration and to support the construction of a wall on the southern border.[49]

58. *The Border Crossed Us*—a temporary public art installation on the UMass Amherst campus.

And at Baylor University in 2012, photographs were made public of female students wearing ponchos, sombreros, mustaches, and makeup resembling dirt on their faces as they climbed over a makeshift wall, prompting an official university inquiry into whether the costumes were racist. Only the costumes—not the wall itself—were called into question.[50]

But a wall constructed of sandbags in 2016 by Kappa Alpha at Tulane University was immediately challenged for being offensive and eventually dismantled by the university football team, even though Kappa Alpha representatives said they wrote "Make America Great Again" on it to mock the ideology of a political candidate.[51]

University Wall

The mission of the University of Texas at Brownsville is in part to draw upon "the intersection of cultures and languages at the southern border"[52] by promoting the close ties it has with Mexico. The university offers courses in both English and Spanish and graduates bilingual teachers; approximately 400 of the university's 17,000 students commute from Mexico. In 2008, however, U.S. Customs and Border Protection planned for an 18-foot-tall borderwall to be constructed directly through the heart of the campus. The wall would have required some students to move through border checkpoints with passport in hand in order to attend their classes.

The wall would have also cut off from the main campus the university's golf course (built in the 1950s for Mexican Americans who couldn't play at the local country club) and part of the baseball field (see "Field of Dreams"). Ironically, it would have also conceptually ceded Fort Texas, an important stronghold in the Mexican-American War, back to Mexico by placing it on the "Mexican side" of the wall. The federal government threatened to condemn and seize the land using its power of eminent domain in the event of opposition to the project.

University officials requested that a federal judge force government officials to work on alternatives to the wall, and the Department of Homeland Security later sued the university for refusing to allow surveyors onto its property.[53] U.S. Customs and Border Protection did present an alternative to the wall, however—it proposed stationing a Border Patrol agent every 50 yards around campus, a plan that would have cost $71 million in salaries alone (see "Human Wall").

Ultimately, the university accepted a plan to "upgrade" an existing fence on campus to a $1.04-million, 10-foot-high wall featuring cameras and sensor technology that would also serve as a laboratory for security infrastructure. The Fort Brown Memorial Golf Course, which is surrounded on three sides by the international boundary—and now on its fourth side by this wall—exists in a geographic limbo somewhere between Texas and Mexico on the "Mexican side" of the wall. To add irony to the confusion, a sign near the sixteenth-hole tee box reads "Do not hit golf balls into Mexico—Violators will be prosecuted"—something no longer possible because the historic golf course is now closed. (See "Field of Dreams.")

Birthing Wall

Casa de Nacimiento was a natural birthing center in El Paso, Texas, many of whose clients were pregnant women from Juárez who had crossed the bridge into El Paso for the day to give their children the advantage, courtesy of the Fourteenth Amendment, of being U.S. citizens. For many years, the owner, Linda Arnold, was one of the "busiest midwives in the state," with a steady stream of female clients, some with their clothes still wet from being pulled across the Rio Grande on inner tubes to reach the birthing center.[54] In 2011, Casa de Nacimiento closed "in compliance with Texas Birth Center Regulations," as the company website stated.[55]

One of the arguments in the United States about immigration has to do with what some call "anchor babies," an offensive term for children born to immigrant parents on U.S. soil, thus

giving the child automatic U.S. citizenship. But with an estimated 40,000 acres of U.S. soil lying on the "Mexican side" of the borderwall, perhaps women need not venture far. Imagine if mobile birthing clinics could simply park alongside the wall, firmly on U.S. soil but on the Mexican side, giving automatic citizenship to those living behind the wall, while at the same time further exposing the wall's inadequacies.

Stone Wall

The throwing of rocks, bottles, and other debris, such as chunks of asphalt or concrete, across the borderwall is the most common form of assault against Border Patrol agents.[56] These "rockings," as they are known among agents, have caused both injuries to personnel and damage to their equipment.[57] In some instances, rock throwing is a random act of violence against U.S. Border Patrol agents; in others, it is a distraction tactic, allowing people to cross in a different location. It can also be a response from the Mexican side to an apprehension on the U.S. side.

This phenomenon can have devastating consequences, both from the rocks thrown from the Mexican side and from reactions from the U.S. side. Injuries to U.S. Border Patrol agents are perhaps the most obvious consequence of rockings; between 2011 and 2013 there were 524 rock attacks against agents on the border.[58]

Rock throwing has also damaged equipment, particularly Border Patrol vehicles. Perhaps the most extreme example was the downing of the helicopter 74 Fox in 1979, when a stone struck the chopper's tail rotor as it was performing low-altitude surveillance near the Tijuana River. The chopper crashed on its side, but fortunately both passengers survived. This was not the only instance of a rock bringing down a helicopter. In 2005, an A-Star helicopter flying near the U.S. port of entry at Andrade, California, was struck by a rock, damaging the rotor and forcing it to make an emergency landing.[59]

One response by U.S. Border Patrol agents has been to open fire on rock throwers. Between 2010 and 2012, U.S. agents killed eight people after being pelted with rocks, six of whom were on Mexican soil on the other side of the wall.[60] In the 524 rock attacks between 2011 and 2013, agents responded with gunfire 55 times. While some contend that the use of firearms is a disproportionate use of lethal force, others consider rocks to be deadly weapons, though no agent has ever died from a rock attack.[61]

In 2012 the Department of Homeland Security began examining its policy on the use of deadly force along the U.S.-Mexico border.[62] Despite a recommendation by the Police Executive Research Forum (a nonprofit group that advises law enforcement agencies) to stop using deadly force against rock throwers, Customs and Border Protection in 2013 advised their agents to use deadly force if they have a reasonable belief that their lives or the lives of others are in danger.[63]

Field of Dreams

Baseball backstops have been another response to rock throwing. Border Patrol agents in Nogales, Arizona, set up an old baseball backstop near the borderwall in order to protect themselves and their vehicles from rocks and other objects thrown over the fence from Mexico. In other places, the backstops have been integrated into the design of the system of barriers, often being placed between double walls where patrol vehicles drive back and forth.

Rock throwing is often a response to the inequities created by the wall. When agents along the border near the Mexican town of Anapra, outside Juárez, stopped the illegal practice of giving dollar bills and candy to Mexican children through the wall, the children became frustrated and began taunting the agents. The agents retaliated verbally, and the children in turn began hurling rocks at the agents and their vehicles.[64]

What if instead of this type of childishness, a different kind of play were promoted at the border—one that encouraged equality and dismantled the one-sided utility of the border-wall? For example, walls could be designed to accommodate backstops that could be used by children in small border towns to play baseball. Baseball is the most popular sport in many parts of Mexico, including the border regions of Sonora and Baja California.

59

59. Protective shields are built into the system of walls to pro-tect Border Patrol vehicles and agents from projectiles.

60. A makeshift vehicle shield is fashioned from a baseball backstop.

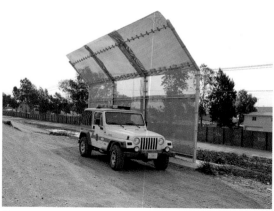

60

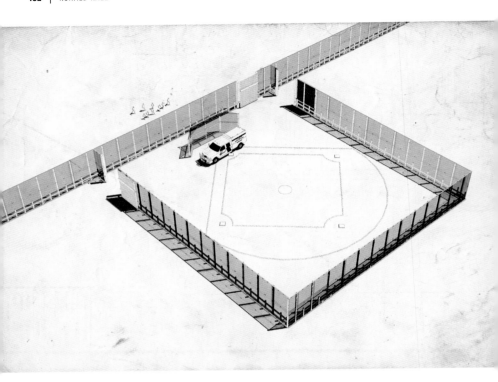

At certain times, agents could even open gates, allowing players to enter onto the baseball field while they patrolled the outer perimeter of the wall. When the field was not in use, agents could close the gates to the field and patrol near the backstop. What would this mean for players who hit a home run? Perhaps if agents were nearby, they could kindly hurl the baseball back over to the other side.

61. A Border Patrol vehicle is shielded by a baseball backstop while children look on.

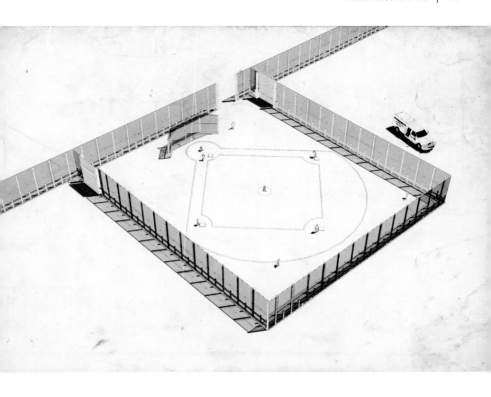

62. A gate opens to allow children
to play baseball in the Field of
Dreams.

Human Wall

The longest human wall—a barrier created by individuals holding hands—was created December 11, 2004, when over 5 million people joined hands to form a human chain 652.4 miles long, stretching from Teknaf to Tentulia, Bangladesh, in a demonstration of no confidence in their government.[65] Prior to this, on May 25, 1986, almost 7 million people raised money to fight hunger and homelessness through the event Hands Across America. People joined hands in a line that stretched 4,152 miles—from New York City's Battery Park to the RMS *Queen Mary* pier in Long Beach, California (the line, however, was not continuous).

In 2013, the Gang of Eight, a bipartisan group of eight senators crafting the 2013 Comprehensive Immigration Reform bill,[66] chose to include an amendment by Senators Bob Corker (R-TN) and John Hoeven (R-ND) called the Border Surge Amendment. It proposed, among other things, the addition of 20,000 Border Patrol agents to the southern boundary, doubling the total number of Border Patrol agents. Shawn Moran, who at that time was the National Border Patrol Council's at-large vice president, said of the amendment, "No one consulted us prior to this coming up. We don't even have the infrastructure to handle 40,000 agents right now."[67]

As long as the economic disparity between Mexico and the United States remains as large as it is now, Mexican citizens will continue to enter the United States illegally. One possible security measure would be for U.S. Border Patrol agents to form a human wall along the 1,969-mile border, a feat that would require around 2 million Border Patrol agents. Considering that Hands Across America raised $34 million in a single day, the effort might be a huge economic boon to the Department of Homeland Security.

Teeter-Totter Wall

The wall was conceptualized as one-sided: a barrier to keep people from crossing from the south. Considering the structure as a single-sided wall represents a poor understanding of the delicate balance of trade and labor relationships between the United States and Mexico. Mexicans come to the United States to find work, but many long to return to live comfortably in their own country. U.S. industry and agriculture depend upon immigrant labor pools, yet the Department of Homeland Security, the Border Patrol, and U.S. Immigration and Customs Enforcement have made it increasingly difficult to attract foreign labor.

Perhaps the best way to represent the mutually dependent relationship between the United States and Mexico is through the construction of a Teeter-Totter Wall. People on both sides could directly experience the interdependency between the two countries by enacting the mutual give-and-take required of two nations whose economic success literally hinges upon their relationship with each other. The borderwall and the cities it divides would be a symbolic and literal fulcrum for U.S.-Mexico relations.

63. A souvenir from the Teeter-Totter Wall.

(OVERLEAF)
64. Teeter-Totter Wall.
Concept drawing on original
plat of U.S.-Mexico border.

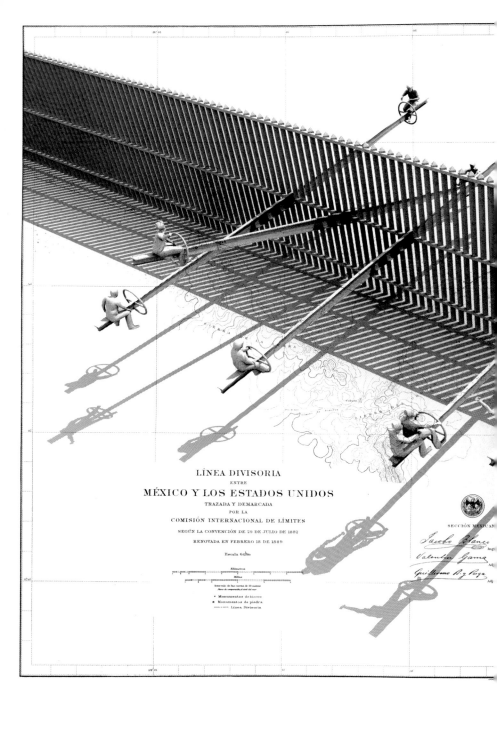

LÍNEA DIVISORIA
ENTRE
MÉXICO Y LOS ESTADOS UNIDOS
TRAZADA Y DEMARCADA
POR LA
COMISIÓN INTERNACIONAL DE LÍMITES
SEGÚN LA CONVENCIÓN DE 29 DE JULIO DE 1882
RENOVADA EN FEBRERO 18 DE 1889

Escala 6:500

Kilómetros

Millas

Intervalo de las curvas de 20 metros
Plano de comparación el nivel del mar

• Monumentos de hierro
■ Monumentos de piedra
‒‒‒‒‒ Línea Divisoria

SECCIÓN MEXICANA

Jacobo Blanco Ing.
Valentín Gama Ad.
Guillermo B. y Puga Ad.

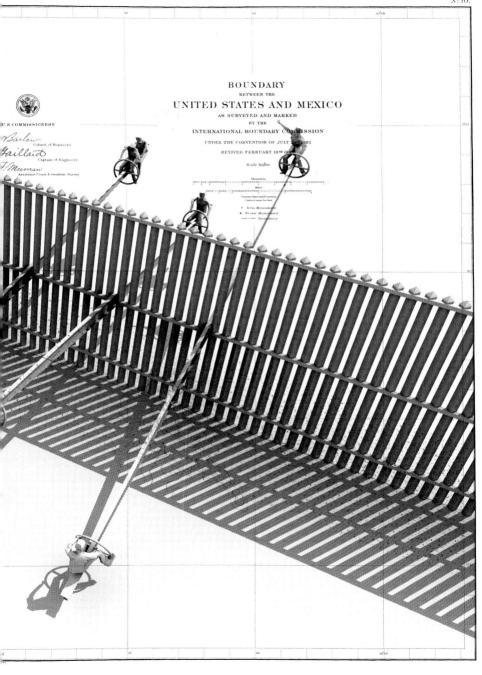

BOUNDARY
BETWEEN THE
UNITED STATES AND MEXICO
AS SURVEYED AND MARKED
BY THE
INTERNATIONAL BOUNDARY COMMISSION
UNDER THE CONVENTION OF JULY 29 1882
REVIVED FEBRUARY 18ᵗʰ 1889

Scale 6 miles

Iron Monument
Stone Monument
Boundary

U.S. COMMISSIONERS

Barlow
Colonel of Engineers.
Gaillard
Captain of Engineers.
J. Mosman
Assistant Coast & Geodetic Survey.

Wildlife Wall

The borderlands between the United States and Mexico comprise grasslands, mountains, and deserts—habitats that support a diverse range of wildlife. Many ecologists and wildlife specialists cite the wall's detrimental effects on wildlife. The wall, both existing and proposed, either cuts through or is adjacent to several wildlife refuges and nature preserves due to the Secure Fence Act of 2006, which waived environmental regulations for the wall's construction despite potential damage to habitats.

The Lower Rio Grande Valley alone hosts seventeen endangered or threatened species. Preventing the free movement of critically endangered species between Mexico and the United States will have detrimental effects on breeding and the diminished access to genetic diversity for those animals due to the isolation caused by the wall. The wall also keeps animals from traveling their natural migration paths in search of water and food.

The greatest concern, however, is that the barrier will break already small populations of animals into even smaller groups, resulting in fewer animals interacting. For animal species with low populations and specialized habitats, the wall can reduce ranges by as much as 75 percent and could ultimately lead to their extinction.[68] These include the arroyo toad, the California red-legged frog, the black-spotted newt, the Pacific pond turtle, and the jaguarondi, which are already on threatened or endangered species lists and are among the species most threatened by the construction of the wall.

65. Wildlife Wall sketch demonstrates how animals can be allowed access to water by making alterations to the wall.

While some walls have been built with open-
ings for small wildlife, the spaces do not
accommodate larger animals, and most
animals do not go in search of holes
to pass through; there is no evidence
that animals are actually using the
holes that were designed for them.
In addition, animals often cannot
burrow under the wall, whose foun-
dation is 9 feet deep in places.

Terrestrial creatures aren't the
only ones affected by the wall.
Although birds can fly over the
barrier, the destruction of the
riparian habitat along the Rio
Grande/Rio Bravo has left fewer
places for birds to live and breed.

Low-flying ferruginous pygmy owls avoid large
open areas like the denuded landscape near the border.
And fewer than one-quarter of their flights are higher than
the average height of the borderwall, further limiting their
range.[69] Electric lighting (see "Light Wall") also poses a great
threat to wildlife: floodlights disorient the jaguarondi, an
oddity of the feline world that hunts during daylight, as well
as nocturnal hunters such as ocelots, bats, and several bird
species.

66. Deer attempting to access a
water source on the other side of
the borderwall.

Ecosystem connectivity is crucial for maintaining a healthy
wildlife population. A dedicated Wildlife Wall would provide
gaps, ramps, and sensors; create opportunities for shelter
and safe nesting spots; and could be built in varying heights
sufficient for the passage of native animals while still meet-
ing security requirements. Such a wall could even possibly
invert the relationship between sanctuaries for wildlife and
the United States' portrayal of itself as a sanctuary needing
to be closed off and protected by definite boundaries that
prevent access. A Wildlife Wall that creates more freedom
for wildlife while constraining visitors to particular enclosed
pathways would allow visitors from both countries to experi-
ence nature on both sides of the border.

(OVERLEAF)
67. A Wildlife Wall would allow
animals to use the wildlife
reserves along the U.S.-Mexico
border. Concept drawing on orig-
inal plat of U.S.-Mexico border.

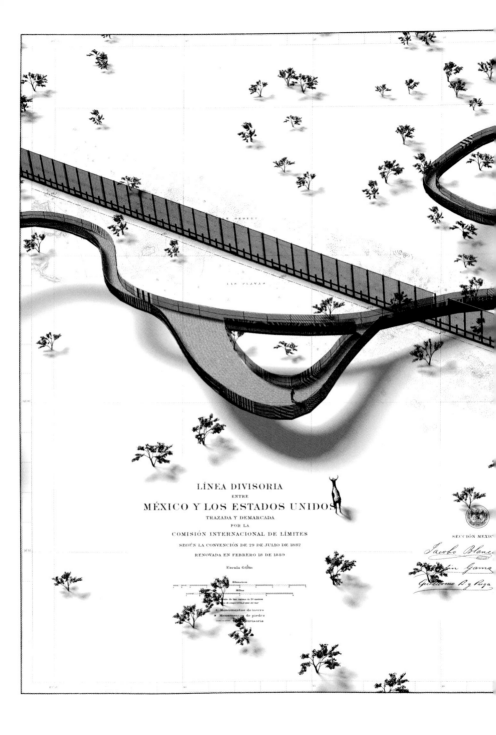

LÍNEA DIVISORIA
ENTRE
MÉXICO Y LOS ESTADOS UNIDOS
TRAZADA Y DEMARCADA
POR LA
COMISIÓN INTERNACIONAL DE LÍMITES
SEGÚN LA CONVENCIÓN DE 29 DE JULIO DE 1882
RENOVADA EN FEBRERO 18 DE 1889

Escala 6/100

SECCIÓN MEXIC°

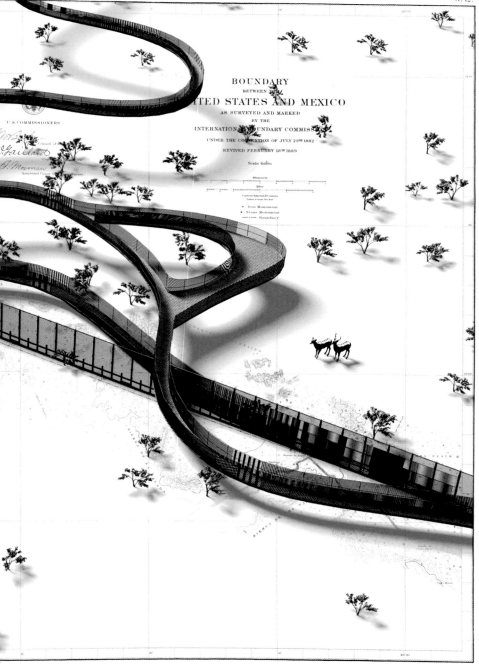

BOUNDARY
BETWEEN THE
ITED STATES AND MEXICO
AS SURVEYED AND MARKED
BY THE
INTERNATIONAL BOUNDARY COMMISSION
UNDER THE CONVENTION OF JULY 29TH 1882
REVIVED FEBRUARY 18TH 1889

Scale 60000

Kilometers

Miles

Contour Interval 20 meters
Datum is Mean Sea level

Iron Monument
Stone Monument
Boundary

U.S. COMMISSIONERS

Forest Wall

In 2008, along the border with Eagle Pass, Texas, Mexicans—
with financial support from their government—began to plant
the first of 400,000 trees that were to eventually become a
"green wall" in protest of the U.S. borderwall. Mexico's Green
Curtain, as it was called, although never entirely completed,
was to extend for 318 miles along the border between the

Mexican state of Coahuila and Texas. According
to Coahuila governor Humberto Moreira, the
planting strategy was to create the longest cor-
ridor of parkland in Mexico. Over 25,000 native
trees were planted, and the project sought to
rejuvenate public green areas in border cities
and offer environmental education through
activities associated with the planting project.[70]

68

While the massive planting campaign was
taking place in Mexico along the border, a
massive excavating campaign was taking place
in the United States. In 2009, approximately
300 sabal palm trees, which can live up to
one hundred years and reach heights of 65
feet, were uprooted because the plans for the
borderwall threatened to destroy them. The last
significant stands of the sabal palm are in the
Lennox Foundation Southmost Preserve and
the Sabal Palm Audubon Sanctuary, both near
Brownsville, Texas, and the Lower Rio Grande Valley National
Wildlife Refuge, near Harlingen, Texas. These three sites,
which protect this rare and vital component of the lower Rio
Grande ecosystem, were directly in the path of a solid metal
and concrete borderwall.

In order to save the trees, the Nature Conservancy, in part-
nership with the U.S. Fish and Wildlife Service and Audubon
Texas, coordinated with the U.S. Army Corps of Engineers to
transplant the trees to other locations nearby. Each tree was
carefully excavated using massive tree-removal equipment
that would keep the root balls intact and undamaged. They

were then transported one by one to various sites and care-
fully replanted.

The reactions on both sides of the border regarding border-
land ecologies demonstrate that an investment in the
propagation and protection of native plantings is important
enough for governments and private organizations to address
the damage caused by the wall. What if the lessons learned
here were used to both manage and protect the last remain-
ing stands of sabal palm along the lower Rio Grande?

Rather than cutting through endangered ecologies, perhaps
a barrier might surround habitats to create hyperprotected
refuges that allow the natural environment to flourish. Such
refuges could be accessible through a very controlled series
of paths so that nature could be experienced (see "Wildlife
Wall") but remain safe from encroachments that would dam-
age the natural ecology in the preserve.

68. A hydraulic tree excavator
removes a sabal palm to trans-
plant it out of harm's way during
construction of the wall.

69. The wall going around, rather
than cutting through, protected
nature areas could create hyper-
protected nature preserves.

69

Solar Wall

In 2011, Republican presidential candidate Herman Cain announced his idea for improving security at the U.S.-Mexico border: an electrified fence that would kill anyone trying to cross the border. One can only wonder what the outcome of Herman Cain's presidential bid would have been had his ideas for the border included, rather than the summary electrocution of impoverished immigrants, something equally outlandish: renewable energy and job creation through the construction of large-scale solar farms along our southern border—a shared infrastructure that would help border communities thrive as part of a thoughtful immigration-reform package.

Currently, the richest untapped potential for solar development in the United States lies along the U.S.-Mexico border. What if some of the funds currently used to maintain the borderwall were reallocated for the construction of energy infrastructure along the border? In many instances, the results would actually be more secure than the existing wall (solar farms are highly secure installations) while simultaneously providing solar energy to the energy-hungry cities of the Southwest.

Consider the 100-mile stretch of border between Nogales, Arizona, and Douglas, Arizona. There, 87 miles of borderwall have been constructed at a cost of $333.5 million. Compare

70. Nogales postcard pre–Solar Wall.

71. Solar Nogales postcard post–Solar Wall.

72. Solar Wall section at port-of-entry station.

73. Solar border-crossing station section.

(OVERLEAF)
74. Solar panels connect, rather than divide, electrical grids across the border.

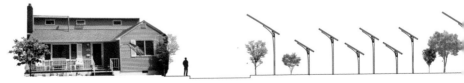

72

73

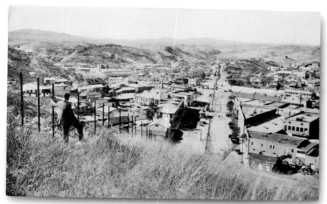

70

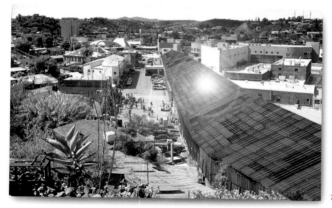

71

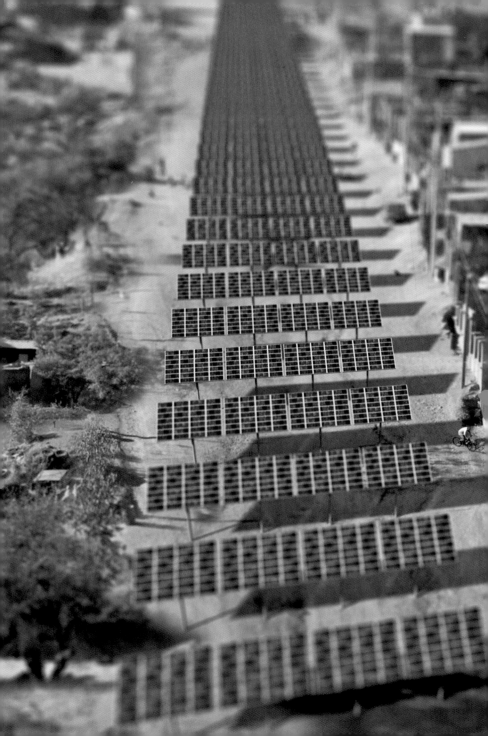

that figure to the cost of one of the largest solar farms in the world—the Olmedilla Photovoltaic Park in Olmedilla, Spain—which cost $530 million. For $333.5 million, 54 miles of 40-foot-wide, profit-generating solar farms could have been constructed, capable of producing 60 megawatts of electricity. Although 33 miles shorter than the existing wall, it would produce enough electricity to power 40,000 households.

Electricity is an important binational commodity. Many border towns already share electrical grids, and electricity could also be sold across the border. Transmission lines along the border could provide reliable electrical infrastructure for both nations to tap.

The potential of a solar border is corroborated by a recent U.S. Environmental Protection Agency brief about the expected expansion of renewable energy production in the United States:

> The U.S.-Mexico border region has a unique abundance of renewable resources that have been and can be used to produce energy, and the region is likely to play a significant role in this expansion. Increased production and use of renewable energy is important to the United States for many reasons: it can help foster our nation's energy independence; it can reduce harmful air emissions commonly associated with fossil fuel energy production; and it draws upon a supply of energy that is inexhaustible. The ability to harness renewable resources will be vital to the United States' future, especially as the nation's population and energy needs continue to grow. The U.S. states along the border with Mexico and the specific communities within the border region will make significant contributions in this area.[71]

A powerful precedent for a successful alternative energy program can be found in Germany, a leader in the new solar economy: Germany's solar farms can produce over 6,200 gigawatt hours per year and have generated over 10,000 jobs.

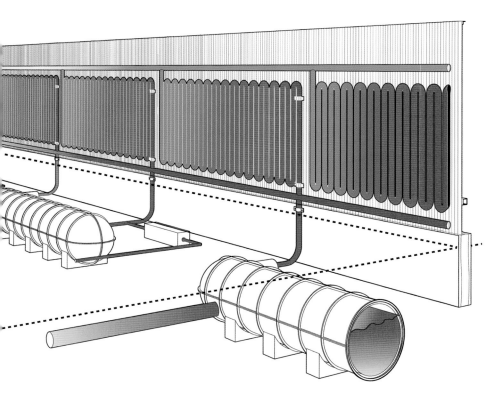

Hot Water Wall

Solar energy can be harvested at the border in other ways. In urban environments, the borderwall could be utilized for hot water production, creating a low-cost resource to supplement the infrastructure of rapidly growing border cities. The massive steel walls—already enormous heat-absorbing agents—could easily be retrofitted with panels that heat water, a much-needed amenity in border cities. The heated water could be stored in insulated underground tanks that would take advantage of the natural insulation of the earth. The stored hot water could then be used in homes, markets, clinics, hospitals, and schools on both sides of the border.

75. Diagram of the Hot Water Wall showing underground water storage.

Life Safety Beacon

The principal cause of death among migrants attempting to cross the border illegally is dehydration. Solar-generated electricity could power beacons attached to the wall that inform Border Patrol agents of both immigrants and American citizens who find themselves in danger in the harsh extremes of the southern deserts. The photovoltaic panels could also be designed to collect water runoff, to power atmospheric water extractors, or to pump water from wells or rivers—water that could then be stored, purified, and dispensed as needed to distressed desert crossers. Engaging the water dispenser or even approaching the life safety beacon would alert the Border Patrol. Such devices might also improve access to water for local wildlife in areas where the borderwall has cut off natural migration routes.

76

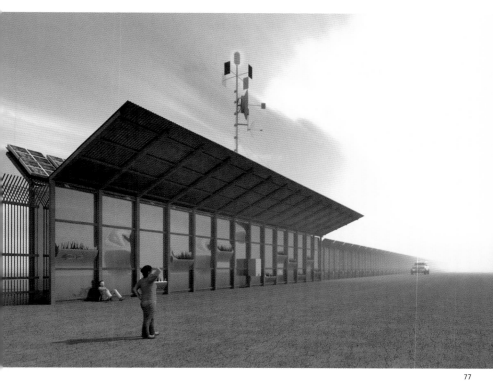

77

76. Life Safety Beacon section.

77. A Life Safety Beacon with
water collection and dispensing
system installed on both sides of
the wall will decrease deaths in
the borderlands.

Wall of Death

The U.S. Border Patrol reports that there were 5,691 border deaths between 1998 and 2013. The number of deaths rose after the passage of the REAL ID Act in 2005 and the Secure Fence Act of 2006. From 1998 to 2004, the average number of deaths per year totaled 313; from 2005 to 2013, that average increased to 423.[72] According to the United States Government Accountability Office, border deaths doubled between 1995 and 2009. Because these numbers do not include those whose bodies have never been found, it is likely that the number of people who have died attempting to cross the border has been underestimated.[73]

The increase in deaths comes at a time when statistics show a decrease in the number of people caught illegally entering the United States from Mexico, possibly indicating that since the increased implementation of the wall as a security measure in 2005, fewer people are being caught crossing illegally because fewer people are attempting to cross, yet more people are dying.

The increase in deaths has been attributed to the walling off of urban areas, forcing desperate migrants to travel through more isolated and rugged geographies where exposure to extreme temperatures can cause hypothermia, dehydration, and heat exhaustion, and where flash flooding in dry riverbeds can cause drowning.

78. The English names John Doe and Jane Doe are assigned to the graves of unidentified people found dead along the border.

Bodies recovered in the Divided States remain in cold storage until they are identified and returned to Mexico. Unidentified immigrants who perish on their journey to the American Dream are placed in particleboard coffins and buried in a paupers graveyard under headstones bearing their hard-won North American–English names of John Doe or Jane Doe.[74]

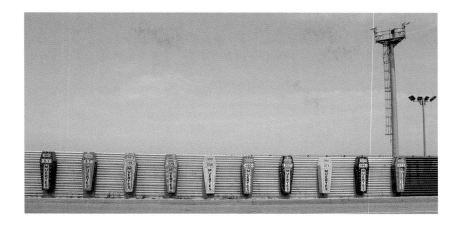

Cemetery Wall

The Tohono O'odham people have for thousands of years inhabited an area extending from what is now central Arizona south to Sonora, Mexico, and east from the Gulf of California to the San Pedro River in southeastern Arizona in an area known as Papagueria.[75] Today, the Tohono O'odham, whose population numbers approximately 20,000, live on the third-largest reservation in the United States, an area of about 4,450 square miles. The Tohono O'odham are one of the few American Indian tribes that have never been relocated from their ancestral lands.[76] But unlike native groups along the U.S.-Canada border, the Tohono O'odham were not given dual citizenship after the Gadsden Purchase, an acquisition by the American

79. A monument at the Tijuana-San Diego border for those who died attempting to cross the U.S.-Mexico border, with coffins representing the year and the number of dead.

80. A wall divides communities of the living and the dead.

government of 29,670 square miles of land from Mexico in 1854, which included the tribal lands.[77]

The customs of the Tohono O'odham, many of whom are Mexican-born, include ceremonies requiring travel back and forth across the border, which they did freely for decades. But in 2007, the U.S. Border Patrol began construction on a 75-mile-long vehicular borderwall through the Tohono O'odham lands, effectively dividing the multinational sovereign nation in half.

While constructing the wall, Homeland Security destroyed sixty-nine graves, which were among eleven archaeological sites identified before the construction of the wall.[78] The remains of direct ancestors of five families living on the reservation were unearthed, and in direct violation of the Native American Graves Protection and Repatriation Act of 1990, three archaeologists boxed, bagged, and removed the remains from the burial site, and their cultural director failed to report their find to the tribal government until two days later.[79] Tohono O'odham chairman Ned Norris Jr. expressed his horror about this event at a congressional field hearing, stating, "Imagine a bulldozer in your family graveyard."

Horse Racing

On March 17, 1957, a horse named Relámpago (Lightning in English, but also known as El Zaino for his chestnut color) from Agua Prieta, Mexico, won a very important race against a horse named El Moro, from the town of Cumpas, to become the champion of Sonora. El Moro was a famous horse in the region—in addition to winning many races, El Moro was seen as the horse of the people, representing the rural and the poor. Relámpago, in contrast, was perceived as the horse of the rich city dwellers. His owner, Rafael Romero, was the proprietor of the Copacabana nightclub in Agua Prieta, and Relámpago had been born in California: "the other side."

The dichotomies between the rich and the poor and between the United States and Mexico imbued this race with great importance—so much so that it inspired one of the best-known *corridos* of all time, "El Moro de Cumpas," composed by Leonardo Yañez and made famous by Vicente Fernández. Later, in 1977, a film by the same name, directed by Mario Hernández, was made in Mexico about the race between El

81. Relámpago and Chiltepín race along the wall that divides Agua Prieta, Sonora, and Douglas, Arizona.

(OVERLEAF)
82. Binational horse racing along the wall. Concept drawing on original plat of U.S.-Mexico border.

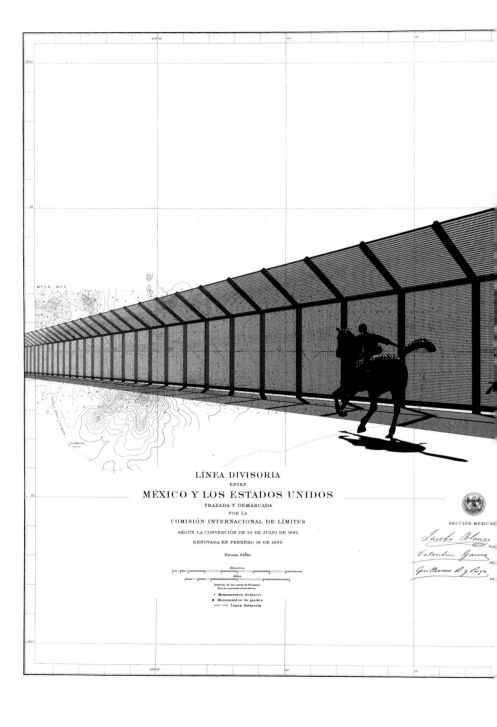

LÍNEA DIVISORIA

ENTRE

MÉXICO Y LOS ESTADOS UNIDOS

TRAZADA Y DEMARCADA

POR LA

COMISIÓN INTERNACIONAL DE LÍMITES

SEGÚN LA CONVENCIÓN DE 29 DE JULIO DE 1882

RENOVADA EN FEBRERO 18 DE 1889

Escala 6ₐₐₐₐ

Kilómetros

Millas

Intervalo de las curvas de 30 metros
Plano de comparación, el nivel del mar

• Monumentos de hierro
■ Monumentos de piedra
— · — · — Línea Divisoria

SECCIÓN MEXICANA

Jacobo Blanco Ing.

Valentín Gama Ad.

Guillermo B. y Puga Ad.

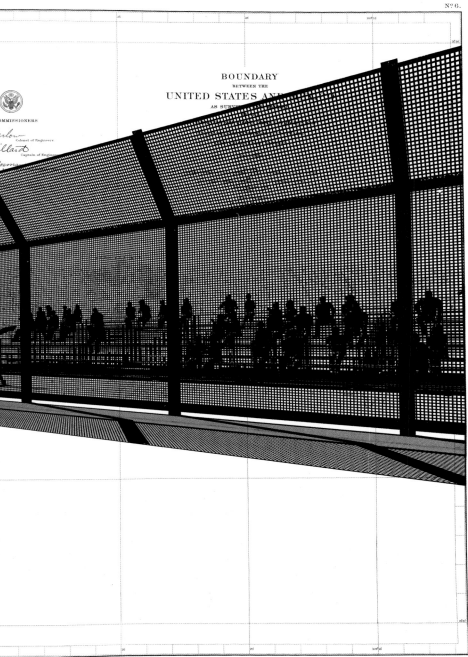

BOUNDARY
BETWEEN THE
UNITED STATES AN[...]
AS SURV[...]

OMMISSIONERS

[...]arlow—
Colonel of Engineers.
[...]illard
Captain of Engineers.
[...]

Moro and Relámpago, starring the famous musician Antonio Aguilar.

After winning the race, Relámpago became famous, and many challenges to his speed were issued on both sides of the border. One challenger, a fiery horse named Chiltepín (after the wild ancestor of the domesticated chile pequín), was set to race Relámpago. Chiltepín was a seasoned horse that had run the Kentucky Derby. But Chiltepín was from Pirtleville, Arizona, just outside Douglas, and although the two owners wanted to race, a hoof-and-mouth epidemic made it impossible for either horse to cross into the other's country.

An ingenious solution was reached: a binational race would take place parallel to the border, with each horse running alongside the boundary. The race was set for September 14, 1958, the bicentennial of Douglas, Arizona.[80] Hundreds of people lined both sides of the border, cheering and betting. Relámpago came off the starting line late and Chiltepín took the lead, but Relámpago quickly closed the gap. The winner after the quarter-mile race: Relámpago![81]

The event in Douglas elevated Relámpago's status from the horse of the rich that beat the horse of the poor (El Moro) to the Mexican horse that defeated the horse from the United States. Like a perceptual wall, the division between the two countries was further solidified by the race, and Relámpago became a beloved horse in Agua Prieta, though his legacy always remained in the shadow of El Moro. Today, a statue of El Moro de Cumpas can be found in the city of Sonora, and while El Moro is well known throughout Mexico, Relámpago is little known outside his region.

On May 5, 2001, forty-three years after the famous race between Relámpago and Chiltepín, the Cinco de Mayo International Border Horse Race was held in Agua Prieta, Mexico, and Douglas, Arizona. The event was a celebration of equestrian sports but also a commemoration of the race that had originally brought people together across the divide and recognized the *transfronterismo* nature of the people (and horses) in the borderlands.

For the race, two miles of barbed wire dividing the United States and Mexico was taken down and replaced with thin, white plastic pipes. The 500 meters of pipe marked not only the division between the United States and Mexico but also the centerline for what was perhaps only the second horse race in the world to take place simultaneously in two countries.

Grandstands were set up on both sides of the border, and nearly 20,000 people lined the track, shouting across the border with jeers, cheers, and bets on who would win. The horses reached speeds of 50 miles per hour in races that lasted between thirteen and twenty seconds.[82] These races have continued to take place despite the increased security along the border. When the fence could no longer be taken down, for years the horses still ran beside a barbed-wire-topped borderwall, which has now been replaced with an 18-foot-tall steel and concrete wall.

And what became of Relámpago and El Moro? In 1966, Relámpago's owner offered a rematch to El Moro's owner. The horses were up in age by then, and El Moro's owner declined to race his thirty-plus-year-old horse, but he offered another horse to race Relámpago. Despite the challenger being a spry three-year-old, Relámpago's owner accepted the offer. Relámpago, also nearly thirty years old, was slow off the starting line again, this time perhaps due to age. He trailed for much of the race but slowly caught up with his challenger, and once again at the finish line: Relámpago!

The rematch solidified the respect for Relámpago in the region. In 1975 he was diagnosed with cancer, euthanized, and given a hero's burial. In some strange way, Relámpago's life was very much a reflection of the wall—from his birth in the United States to his migration to Mexico, and even to the way in which fans linked their perceptions about socioeconomic status with their perceptions of the horse. His rise to hero status came after racing along the fence to win the title of Horse of the People from El Moro.

Light Wall

In many sections of the border, the wall is illuminated from dusk until dawn by large stadium lights. Because of the intensity of this light, the wall blocks not only migration from the south but darkness itself. Many border towns have effectively lost their night. Artificial lighting can disrupt humans' natural sleep-wake cycle as well as suppress melatonin production. And it affects not only people.

Birds become "tower kills" when they fatally collide with light structures or with each other when they are confused by intense artificial light.[83] Nocturnal animals alter their behavior to try to avoid the light.

This literal wall of intense light can even be observed from space, as a line of illumination equal to that of some of the most densely populated areas in the cities it divides.

83. Illuminated borderwall between Tijuana, Baja California, and San Diego, California, seen from space.

Greenhouse Wall

In northern climates, large football stadiums such as the Green Bay Packers' Lambeau Field grow lush grass during the winter months by using stadium grow-lights. As stadium lights are also used along several miles of the border fence, our border-security illumination system might use this technology to create a much more productive border. Rather than just miles of illuminated wall, miles of greenhouses could be constructed to take advantage of the sunny borderland regions. And, since the artificial sun never sets on these militarized landscapes, productivity could be increased by using stadium grow-lights to extend the growing process into the nighttime hours.

One can only speculate how long stretches of hyperproductive greenhouse walls might enhance or complicate U.S. reliance on foreign labor for agriculture. If the border itself were transformed into a mega-agricultural zone, migration north could be affected, especially to regions such as Yuma,

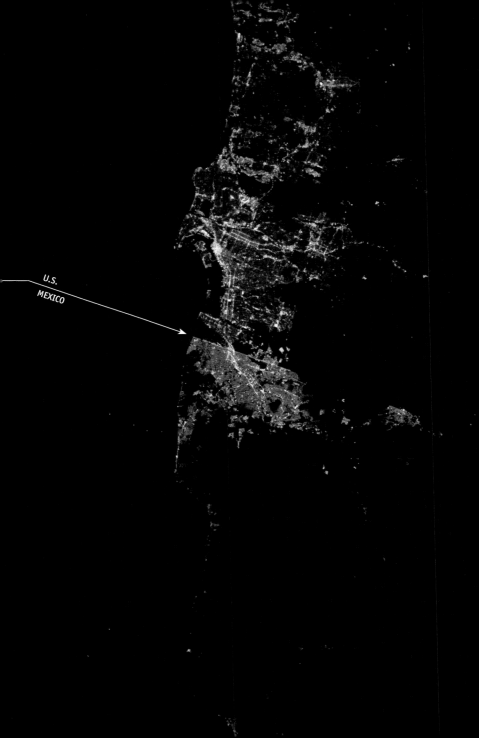

U.S.

MEXICO

Arizona (the "winter vegetable capital of the nation"), and California's Imperial Valley and Salinas Valley (the "salad bowl of the world"). With the recent legalization of marijuana in certain U.S. states hurting Mexican drug cartels,[84] perhaps the cultivation of medical marijuana in these megagreenhouses would further cripple the drug trade that fuels the violence in border cities and throughout Mexico.

84. Greenhouse Wall sketch.

85. A Greenhouse Wall straddles the border and is illuminated twenty-four hours a day by sun and stadium lights. Concept drawing on original plat of U.S.-Mexico border.

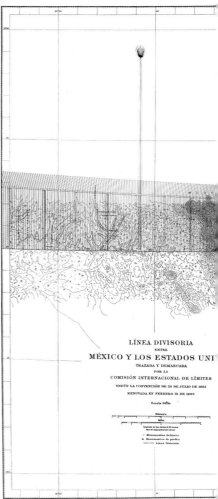

LÍNEA DIVISORIA
ENTRE
MÉXICO Y LOS ESTADOS UNI
TRAZADA Y DEMARCADA
POR LA
COMISIÓN INTERNACIONAL DE LÍMITES
SEGÚN LA CONVENCIÓN DE 29 DE JULIO DE 1882
RENOVADA EN FEBRERO 18 DE 1889

85

84

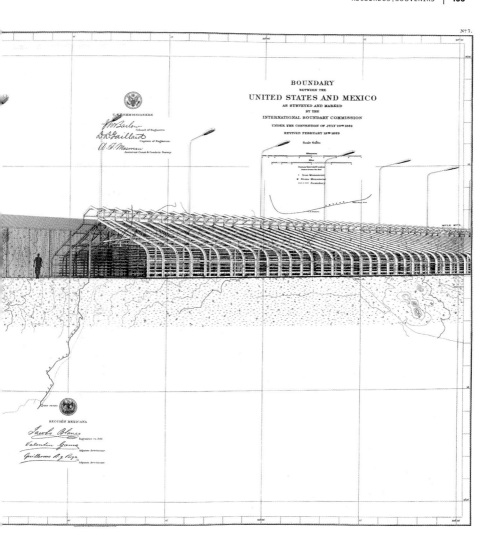

BOUNDARY
BETWEEN THE
UNITED STATES AND MEXICO
AS SURVEYED AND MARKED
BY THE
INTERNATIONAL BOUNDARY COMMISSION
UNDER THE CONVENTION OF JULY 29ᵀᴴ 1882
REVIVED FEBRUARY 18ᵀᴴ 1889

Gallery Wall

Some might consider the wall itself to be an enormous work of art, much like Christo and Jeanne-Claude's *Running Fence* (1976), an 18-foot-high wall of fabric that stretched across 24.5 miles of Northern California, inspired by the fences demarcating the Continental Divide. Like *Running Fence,* the borderwall is a horrifically beautiful and widely photographed land installation, meandering for miles before reaching its finale 30 feet into the waters of the Pacific Ocean. As noted by author Marcello Di Cintio, "Christo's fence fluttered in the wind. It reflected light. . . . Today's fences are built with concrete, steel, and wire meant to tear flesh. Aside from the occasional siren wail, these fences are silent."[85]

Along many stretches of the border, the wall actually serves as a platform for displaying art. Most of the art is in protest of the wall or brings to light the consequences of the wall (see "Wall of Death"), and some of it is graffiti. Mixed media, physical sculpture attached to the wall, painting, performance art, video projection, and memorials to the dead are just a few of the ways artists have engaged the wall. Perhaps it is the world's largest gallery wall, enticing artists to find representation somewhere along the hundreds of miles available to them.

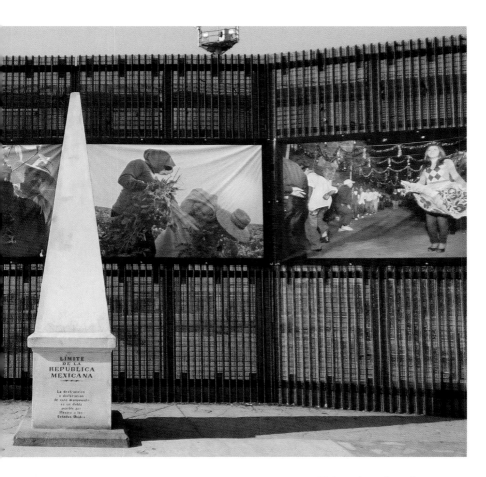

86. Artwork transforms the borderwall into an art Gallery Wall at Playas de Tijuana.

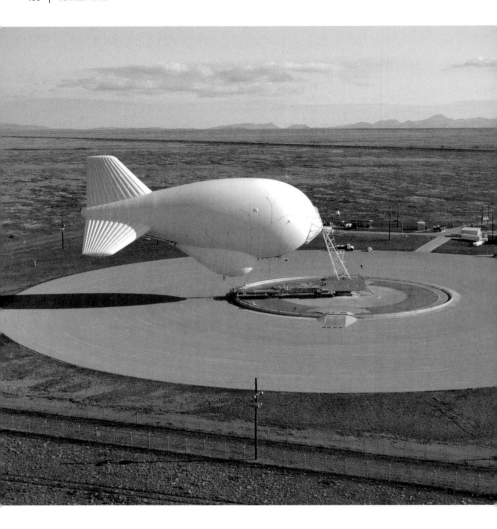

Virtual Wall

Not all walls constructed along the border are physical. In 2006, the Secure Border Initiative (SBI) launched SBInet, a program for introducing technology infrastructure to create a virtual wall along the border. The U.S. Department of Homeland Security awarded the first phase of SBInet, called Project 28, to Boeing, giving it a three-year, $67-million contract to implement technology along the border. If Project 28 proved a success, SBInet estimated that full implementation of security towers along both the Canadian and Mexican borders would come at a cost of $2 billion–$8 billion.

The intended technology included drones, ground sensors that could detect both sound and movement, and infrared and optical sensors that could relay data to Border Patrol agents' laptops via satellite. High-resolution cameras, radar, and real-time video were also slated to be implemented.

In all, 53 miles of the Arizona border were equipped with advanced (and expensive) technology. But problems arose when the system was put into use by the Border Patrol. The sensors could not distinguish between humans and wildlife, the software was buggy, and the extreme weather of the Arizona desert caused equipment to malfunction.[86]

In 2011, the Department of Homeland Security canceled the Virtual Wall project, citing unmet viability standards and high costs. A total of $1 billion in taxpayer dollars was invested in the project over the five years it was in operation, with little to show for it but memories of a boondoggle in which $2 million per mile floated away like the aerostat blimps it helped fund.

87. Tethered aerostat blimp near Marfa, Texas.

Floating Wall

Floating atop the ever-changing Algodones and Imperial Sand Dunes between Yuma, Arizona, and Calexico, California, this massive 15-foot-high wall is constructed of steel tubes welded together every few inches to form an impenetrable barrier. The structure, called the Floating Fence, but also known as the Sand Dragon because of the way its menacing rusty spines undulate atop the dunes, is continually engulfed by the ever-shifting sand. To prevent dune migration from swallowing the dragon completely, the $40-million, 7-mile-long wall is designed to be periodically exhumed from the sand using a special machine and then resituated atop the morphing topography.

Instead of a massive $6-million-per-mile "sinking wall" made of steel, why weren't a lightweight photovoltaic fabric and aerostat blimps employed to create a wall that could literally float? This would visually define the border through energy production (see "Solar Wall") and high-tech surveillance for life safety (see "Life Safety Beacon"). In a way that is reminiscent of Christo and Jeanne-Claude's *Running Fence*

88. The Floating Wall, also known as the Sand Dragon, is built atop the Algodones Dunes in Southern California and continually sinks in the sand.

89. Aerostat blimps hold a floating curtain in an ephemeral demarcation of the border.

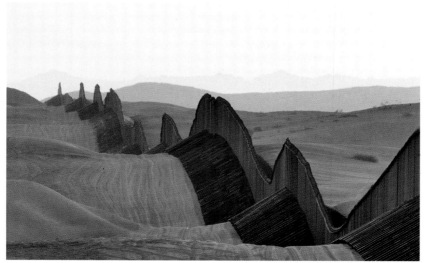

(see "Gallery Wall"), it could have also literally floated away when no longer needed.

One group, comprising Native American and mestizo artists, known as Postcommodity, has created a work that does indeed float above the border. In 2015, they deployed an installation entitled *Repellent Fence*.[87] Located near the sister cities of Douglas, Arizona, and Agua Prieta, Sonora, the group inflated twenty-six 10-foot-diameter, helium-filled balloons and tethered them to float 50 feet above the desert and perpendicular to the borderwall on each side for 2 miles.

The balloons were enlarged replicas of what the artists call "an ineffective bird repellent product." However, the colors and graphics were similar to ones in indigenous healing iconography, thus symbolically challenging the nature of the wall as an ineffective repellent and celebrating the potential for creativity to heal and stitch together the lands that the wall divides.

90. *Valla Repelente/Repellent Fence* floats above and transects the borderwall, creating a conceptual stitch in a divided landscape.

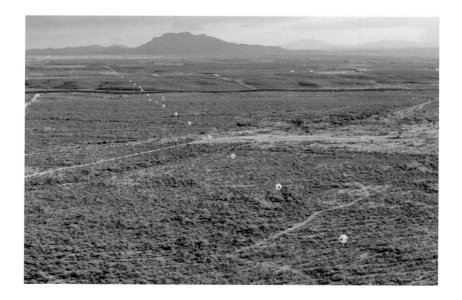

Gated Communities

Along certain stretches of the border, particularly in the lower Rio Grande region, the borderwall's straight-line vector must compete with the river's geography—an array of avulsions creating countless oxbows. The river's nature combined with an international treaty that prohibits building the wall in a flood zone has resulted in the wall sometimes being placed more than one mile from the political border as defined by the meandering river. This has left several private landowners isolated behind the 15- to 18-foot-tall borderwall, and their land— much of it farmland, but several houses too—trapped on the "Mexican side" of the borderwall.

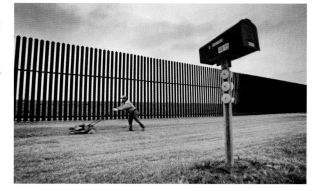

Max Pons is a fifth-gener- ation Texan whose home has been walled off by the construction of a 15-foot-tall steel barrier. Gates have been installed to allow Pons to travel through the barrier, but when the large motorized panels (controlled by government-is- sued passcodes) slide shut behind him, he finds himself in a no-man's-land sandwiched between the actual border and the wall. Even though the gates stay open for several hours each day at the discretion of the Border Patrol, residents can also be shut behind the gates, feeling trapped.[88]

91. Lying hundreds of yards north of the political border, the borderwall divides several private properties, making residents feel isolated.

Tim Loop's home lies less than 400 feet from the 18-foot-tall steel fence.[89] His family has lived on this land, tucked into the southernmost tip of Texas, for three generations. Here, they have grown cotton, soybeans, wheat, cabbage, corn, sorghum, and sugarcane. Yet now when Loop stands on his front porch, he must look through the small gaps in the wall to see the rest of the United States.

To construct the wall, approximately four hundred properties were removed from public ownership through eminent domain. Dr. Eloisa Tamez, an activist, nurse, and Lipan Apache, was born in 1935 and lives on land granted to her ancestors by the king of Spain in 1767.[90] She was offered $13,500 by the U.S. government for a 50-foot-wide strip of land that runs across her three acres west of Brownsville, Texas. She refused the offer. In 2008, Michael Chertoff, then secretary of the Department of Homeland Security, threatened to sue Tamez and condemn her land through the power of eminent domain unless she cooperated with the federal government. Tamez again refused and filed suit against the Department of Homeland Security and Secretary Chertoff.[91]

In 2009, a district court granted permission to the Department of Homeland Security to proceed with construction of the wall on her property through eminent domain, but required that the department consult with her regarding the construction. Ignoring this court order, within forty-eight hours Homeland Security had constructed an 18-foot-tall steel wall on her land, cutting her off from the southern portion of the property her family has lived on for over two hundred years.[92] Tamez eventually received $56,000 for her land from the federal government, which she used to establish a scholarship at the University of Texas Rio Grande Valley, where she is a professor.[93]

House Divided

On the U.S. side, the borderwall cuts through private property, sequesters residents on the southern side of the fortress, and sometimes even encroaches on occupied residences. In Mexico, there is, according to architect Teddy Cruz, "zero setback,"[94] meaning that houses on the Mexican side can come up directly to the wall.[95]

What if there were zero setback on the U.S. side as well? Perhaps families on the U.S. side would build against the wall as a means of bringing separated families together under one

92. With a zero setback on both sides of the wall, the wall itself could be an integral component of a house, and possibly other communities, but what in the domestic environment would it continue to divide?

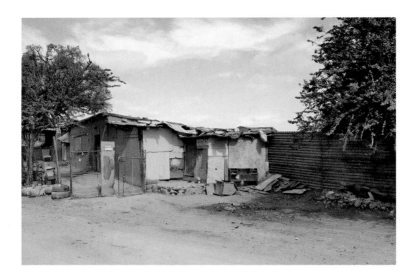

roof. Varying construction methods would come into play, employing different materials and representing different economies, space and comfort needs, and efficiencies. But even in the case of two houses adjoined by the wall, there would be a division. Architects would perhaps seek to design some sense of equanimity in the division of living rooms, bedrooms, bathrooms, and dining rooms, creating homes that are the architectural equivalent of conjoined twins—sharing a common organ.

93. A home in Colonia Libertad, Tijuana, Baja California, which uses the borderwall as a wall in the house. Photographed by Richard Misrach for his Border Cantos series.

94. Blueprint for a House Divided constructed through the kitchen table.

95. Blueprint for a House Divided constructed through the living room.

(OVERLEAF)
96. Blueprint for a House Divided constructed through the bathroom.

97. Blueprint for a House Divided constructed through the bedroom.

94

95

96

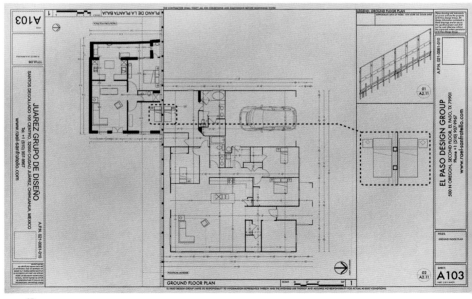

97

Earth Wall

Smuggler's Gulch was once a narrow canyon of coastal scrub defined by two mesas just a few miles from the Pacific Ocean. The canyon's name came from its storied past as a conduit for cattle thieves, drug smugglers, and booze runners during Prohibition. Later, it was considered a dangerous landscape where bandits would attack immigrants attempting to cross through the canyon; even Border Patrol agents did not venture there alone. The gulch is also a natural drainage that carries episodic streams from Mexico into the Tijuana River Estuary, which for several decades has been one of the nation's largest wetland restoration projects, comprising 520 acres of intertidal ecology.

In 2008, however, the canyon was filled with close to 2 million cubic yards of dirt excavated from the tops of the two surrounding mesas and piled 180 feet high,[96] filling approximately half the length of the gulch.[97] A road, stadium lights (see "Greenhouse Wall"), and a 15-foot-tall triple wall were built atop the berm, which was part of a $60-million project to install 3.5 miles of wall. At the base of this enormous Earth Wall lies a 680-foot-long culvert that hastens water into the estuary, flooding ranches and depositing silt and erosion from the massive earthwork project into the estuary, damaging the habitat of native plants and animals.

98. Two million cubic yards of dirt fill Smuggler's Gulch, creating an enormous wall of earth.

Fire Wall

In construction, a fire wall is a barrier that prevents the spread of fire between or through buildings. But when a fire erupted at the Hotel San Enrique in Nogales, Sonora, an establishment known to house migrants waiting to attempt to cross the border, the borderwall served as a kind of fire wall. Ten Mexican fire trucks responded to the blaze but had difficulty putting out the flames. Then the Nogales, Arizona, fire department arrived with the city's never-before-used $827,000 ladder truck with its 5-inch hose. The truck extended its tall ladder into the air over the fence and into Mexican airspace and quickly contained the flames, preventing their spread to the neighboring building (and country).

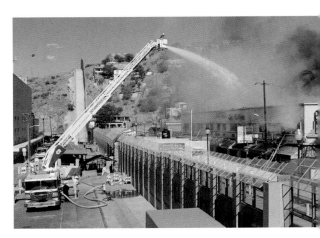

99. A Nogales Fire Department ladder truck breaches the wall to help extinguish flames across the border.

Invisible Wall

Night after night, the borderwall is continually erased. In one year, in the stretch of wall between Otay Mesa and San Ysidro, California, several hundred holes are cut out of the wall with blowtorches—openings large enough for a person to crawl through. The cost to hire welding crews to seal the cuts in the wall amounts to $9 million per year.[98]

Ana Teresa Fernández, an artist from Tampico, Mexico, who now lives in San Francisco, California, participates in erasing the wall—but not with welding leathers, protective eyewear, and a blowtorch. Instead, she wears a black dress and stilettos, and wields a paintbrush. She has created a series of installations called *Borrando la Frontera* (Erasing the Border) in California, Texas, and Arizona with the intention of visually

dissolving the border and sparking conversation, community awareness, and active participation toward a conceptual and, ultimately, physical, dissipation of the wall into the sky and water.

By selecting paint the color of the sky, Fernández subverts the prison-like solidity of the rusty steel of the borderwall with a thick coat of blue paint so that the columns become one with the gaps between them, creating a visual illusion— and perhaps for some, a premonition—that the wall is no longer there.

Residents of Tijuana have taken much pride in this installa- tion, protecting it from others painting over it or removing it. In many ways, they consider it a kind of monument—an invisi- ble monument. The irony is that if the wall is ever dismantled, Fernández's invisible wall might remain.

100. The rusted metal wall dissolves into sky, sea, and sand in Ana Teresa Fernández's project *Borrando la Frontera* at Playas de Tijuana, Mexico.

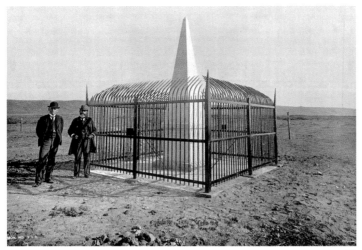

101

Monumental Wall

The wall itself is a monumental construct. Long after the optimistic possibility of its removal, evidence of the wall's presence will remain in the environmental, genetic, cultural, topographical, geological, and ecological transformations it has created. But many monuments have marked the border's presence since its inception as a physical entity.

The first monuments were in the form of cairns, piles of stones stacked by the earliest surveyors of the border. Later, more formal monuments were cast from concrete or bronze and situated along the political border.

With the militarization of the border, the historic monuments were often an obstacle to wall construction. In some cases, the wall would detour around the monument, and in other cases, the wall would stop at the monument and continue on the other side.

Today, many of these historical monuments are completely inaccessible—surrounded by the borderwall, hidden from view, and locked behind gates to which there are seemingly no keys.

101. The first boundary point established after the Treaty of Guadalupe Hidalgo was marked with a marble monument, which was later walled off to prevent vandalism.

102. Monuments memorialized as keychains without keys.

103. Just west of Douglas, Arizona, and Agua Prieta, Sonora, is Border Monument No. 87, which lies locked away behind the borderwall. This photo comes from David Taylor's book *Monuments.*

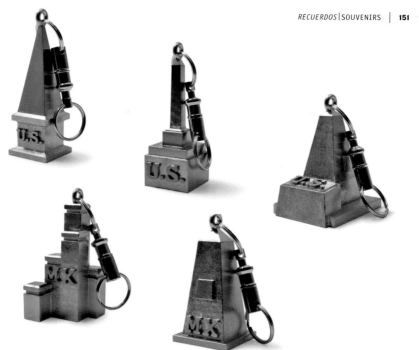

102

103

Labyrinth Wall

The primary difference between a labyrinth and a maze is that a maze is a multicursal design with a number of complex, branching choices intended to make people lose their way, whereas a labyrinth is a unicursal design with only a single path leading from its entrance to its goal via a tedious and winding route.

The journey people take to get to the wall and the nation beyond it might best be described as labyrinthine—there is a single intended destination for an immigrant coming to the United States from the south, but the path is long and winding. It is somewhat surprising that the Army Corps of Engineers has not yet envisioned the wall as a tortuous (and expensive) labyrinth. Such a barrier would be much more difficult to navigate, making the three-tiered walls seem like child's play (see "Board(er) Game").

104. A Labyrinth Wall sketch.

105. A wall built as a labyrinth has only a single path, from south to north, irrespective of the number of layers in one's journey.

LABYRINTH WALL
 MAZE

104

1. A course charted with Google Maps through several of the popular destinations of the Grand Tour (from London through Paris, Barcelona, Rome, and Naples) is 1,937 miles by car.

2. Ludwig Wittgenstein, *Philosophical Investigations*, 499.

3. The Department of Homeland Security specifically uses the word *alien* in its border calculus diagram. See "DHS Describes the 'Border Calculus,'" *Homeland Security Watch*, November 20, 2006, www.hlswatch.com/2006/11/20/dhs-describes-the-border-calculus/.

4. Richard M. Stana, "Secure Border Initiative: Observations on Selected Aspects of SBI*net* Program Implementation" (United States Government Accountability Office testimony, GAO-08-131T, October 24, 2007), www.gao.gov/new.items/d08131t.pdf.

5. Richard Marosi, Cindy Carcamo, and Molly Hennessy, "Immigration Reform's First Hurdle: Is the Border Secure?" *Los Angeles Times*, March 10, 2013, local sec.

6. Quoted in Richard Marosi, "Fence Lab Scales New Barriers: U.S. Seeks Blockade That Will Keep Out Crossers, but Nicely," *Chicago Tribune*, November 19, 2007, http://articles.chicag-otribune.com/2007-11-19/news/0711180218_1_aircraft-landing-mats-fence-styles-bor-der-patrol.

7. Richard M. Stana, "Secure Border Initiative: DHS Has Faced Challenges Deploying Technology and Fencing along the Southwest Border" (United States Government Accountability Office Congressional Testimony, GAO-10-65IT, May 4, 2010): 2, www.gao.gov/new.items/d10651t.pdf.

8. Chad C. Haddal, Yule Kim, and Michael John Garcia, "Border Security: Barriers along the U.S. International Border" (CRS Report for Congress no. RL33659, Congressional Research Service, March 16, 2009): 25, https://www.fas.org/sgp/crs/homesec/RL33659.pdf.

9. Marosi, "Fence Lab Scales New Barriers."

10. "Progress in Addressing Secure Border Initiative Operational Requirements and Constructing the Southwest Border Fence" (Office of Inspector General, Department of Homeland Security, OIG-09-56, April 2009), www.oig.dhs.gov/assets/Mgmt/OIG_09-56_Apr09.pdf.

11. Chris McDaniel, "Smugglers Improvise Ramp to Drive over Border Fence," *Yuma Sun*, April 8, 2011.

12. Tim Gaynor, "As Border Tightens, Smugglers Raise Their Game," *Reuters*, March 10, 2008, www.reuters.com/article/2008/03/10/us-usa-border-smugglers-idUSN0662194320080310.

13. The first accounts of biolog-ical warfare involved the use of catapults to launch the bodies of diseased humans over walls to

infect the populations protected within.

14. The first human cannonball was a 14-year-old girl named Rossa Matilda Richter, an immigrant to the United States, who was launched from a cannon in 1877; she later toured with the P. T. Barnum Circus.

15. Jamie Hyneman and Adam Savage, "Border Slingshot," *MythBusters*, Discovery Channel, season 3, July 27, 2005.

16. The event, a performance art piece entitled *One Flew Over the Void,* was conceived by Venezuelan artist Javier Tellez as part of inSITE, a periodic exhibition conceptualizing the spatial and mental nature of borders.

17. Marc Lacey, "Arizona Officials, Fed Up With U.S. Efforts, Seek Donations to Build Border Fence," *New York Times*, July 20, 2011, New York ed., U.S. sec.

18. Roy Germano, "Race to the Top—2 American Women Climb US-Mexico Border Fence in Less than 18 Seconds" (video), uploaded December 16, 2010, www.youtube.com/watch?v=XHjKBjM1ngw.

19. Khaled Jarrar, "No Man's Land," Culturunners, February 2016, http://culturunners.com/projects/no-mans-land.

20. Lynn Brezosky, "Ranchers Add Ladders to Save Border Fences," *Washington Post*, June 17, 2006, Wires sec., www.washingtonpost.com/wp-dyn/content/article/2006/06/17/AR2006061700175.html.

21. Some Mexicans believe that the spirit of Santo Toribio, a priest who was killed in 1928 and canonized by Pope John Paul II in 2000, has appeared to some undocumented immigrants crossing the border to assist them in distress.

22. Rebecca Calarren, "Battered Borderlands," *High Country News*, September 27, 1999, www.hcn.org/issues/163/5285/print_view.

23. "Travel Management Guidance & Technical Reference," Bureau of Land Management, last updated December 21, 2015, www.blm.gov/wo/st/en/prog/Recreation/recreation_national/travel_management/travel_mgt_guidance.html.

24. "Border National Monument Is Center of Conflict," *Arizona Public Media*, July 13, 2013, www.azpm.org/p/home-featured/2013/7/23/25656-border-national-monument-is-center-of-conflict/.

25. For more information on borderwall-related impacts, see *Organ Pipe Cactus National Monument: Superintendent's 2010 Report on Natural Resource Vital Signs* (Ajo, AZ: National Park Service, 2011), www.nps.gov/orpi/learn/nature/upload/orpi_vitalsigns2010.pdf.

26. Arthur H. Rotstein, "200 Miles of Border Barriers Being Erected," *Tucson Citizen*, May 4, 2007, local sec., http://tucsoncitizen.com/morgue/2007/05/04/50527-200-miles-of-border-barriers-being-erected/.

27. David McLemore, "Texas to See Border Fence Construction Next Year despite Opposition," *Dallas Morning News*, December 5, 2007.

28. George B. Frisvold and Margriet F. Caswell, "Transboundary Water Management Game-Theoretic Lessons for Projects on the U.S.-Mexico Border," *Agricultural Economics* 24 (2000): 101–11.

29. George W. Bush, "Introductory Speech at the Signing of the Secure Fence Act," Washington, DC, October 26, 2006.

30. Nicole Ries, "The (Almost) All-American Canal: *Consejo de Desarollo Económico de Mexicali v. United States* and the Pursuit of Environmental Justice in Transboundary Resource Management," *Ecology Law Quarterly* 35, no. 3 (June 2008): 491–529, http://scholarship.law.berkeley.edu/elq/vol35/iss3/9.

31. Ruben Salazar, "Texas Due to Return 450 Acres to Mexico," *Los Angeles Times,* March 13, 1963.

32. More information on the history of Friendship Park is available at www.friendshippark.org.

33. Joshuah Bearman, "Viva Border Volleyball!" *LA Weekly,* July 26, 2006, www.laweekly.com/2006-07-27/columns/viva-border-volleyball/2/.

34. Cynthia Weber, "Civilians," in *"I Am an American": Filming the Fear of Difference* (Bristol, UK: Intellect [distrib. University of Chicago Press], 2011), 81.

35. Nine years later, in 2016, Tecate produced an advertisement stating that "the time has come to build a wall . . . the Tecate Beer wall . . . a wall that brings us together. . . . You are welcome America." "Tecate Beer Wall Commercial 2016," TV Commercials, YouTube, October 3, 2016, https://youtu.be/dxypxNWKlw4.

36. Tom Miller, "One Land, Two Masters," *Geo* 1, no. 2 (1979): 16. Some three decades later a game of wall y ball was portrayed in a Carl's Jr. advertisement for its Tex Mex Bacon Thickburger. In the ad, two bikini-clad women attempt to settle an argument over the national identity of the burger (Tex or Mex?) in a game of volleyball played over the borderwall. See www.youtube.com/watch?v=EPOcxNMzNhc.

37. Adrian Florido, "Breaking through the Border Fence, by Hand," *Voice of San Diego*, August 25, 2009, http://voiceofsandiego.org/2009/08/25/breaking-through-the-border-fence-by-hand/.

38. "Coming to Homerica," *The Simpsons*, season 20, episode 21, May 17, 2010.

39. Cindy Carcamo, "Border Fence Is Musician's Wall of Sounds" *Los Angeles Times*, January 4, 2014, local sec., 14, www.latimes.com/local/la-na-ffc1-border-music-20140130-dto-htmlstory.html#ixzz2x731TcxI.

40. For Glenn Weyant's SonicAnta project, see www.sonicanta.com/the_anta_project/.

41. The alleged existence of weapons of mass destruction in Iraq became the primary justification for the 2003 invasion of Iraq and the eventual construction of the wall to protect the southern border against the threat of terrorism.

42. Irina Zhorov, "Mexico's HñaHñu Community Battles Illegal Immigration with Simulated Border Crossing, Complete with Gun Shots," *Indian Country Today,* May 30, 2012, http://indiancountrytodaymedianetwork.com/article/mexicos-hnahnu-community-battles-illegal-immigration-with-simulated-border-crossing-complete-with-gun-shots-115536.

43. A *coyote* is a Spanish term for someone who smuggles people illegally across the U.S.-Mexico border.

44. Reed Johnson, "Mexican Town Offers Illegal Immigration Simulation Adventure," *Los Angeles Times,* May 24, 2008, www.latimes.com/news/nationworld/world/latinamerica/la-et-border24-2008may24,0,3605698.story.

45. *Mojado* is a pejorative term for someone who has crossed into the United States illegally by wading across the Rio Bravo/Rio Grande. The word literally means "wet" in Spanish.

46. Stephen Clarkson and Matto Mildenberger, *Dependent America? How Canada and Mexico Construct US Power* (Toronto: University of Toronto Press, 2011), 51.

47. Matthew Hendley, "University of Arizona Mock Border Fence *Kinda* Decries U.S.-Mexico Border Fence," *Phoenix New Times,* March 24, 2011, www.phoenixnewtimes.com/news/university-of-arizona-mock-border-fence-kinda-decries-us-mexico-border-fence-6656039.

48. University Museum of Contemporary Art, *"The Border Crossed Us"* (updated press release), University of Massachusetts Amherst, April 7, 2011, https://fac.umass.edu/ArticleMedia/Files/2011-04-07-BorderUpdatedPR.pdf.

49. Kelsey Husky and Sarah Mason, "Students Erect Fence to Protest Illegal Immigration," *Moscow-Pullman Daily News,* April 14, 2011, http://media.spokesman.com/documents/2011/04/0834_001.pdf.

50. Patrick Frye, "Racist Sorority Photo: Students Dress Mexican, Ask 'Green Card?'," Inquisitr, December 6, 2012, www.inquisitr.com/427156/racist-sorority-photo-baylor-students-dress-mexican-ask-green-card/.

51. Rafi Schwartz, "Bonehead Tulane Frat Brothers Cause Uproar by Building 'Trump Wall' around Their House," Fusion, April 14, 2016, http://fusion.net/story/291335/kappa-alpha-bros-build-trump-wall-around-their-tulane-frat-house-nola/.

52. See the UTB Mission Statement at www.utb.edu/Pages/MissionandPhilosophy.aspx.

53. Christopher Sherman, "Border Fence Would Cut through Texas University," *USA Today,* June 27, 2008, http://usatoday30.usatoday.com/news/nation/2008-06-27-3637785531_x.htm.

54. Andrew Rice, "Life on the Line," *New York Times,* July 30, 2011, www.nytimes.com/2011/07/31/magazine/life-on-the-line-between-el-paso-and-juarez.html.

55. Casa de Nacimiento. www.casamidwifery.com/index.html. Accessed November 1, 2014.

56. Lourdes Medrano, "Bullets vs. Rocks? Border Patrol under Fire for Use of Deadly Force," *Christian Science Monitor,* December 3, 2012, www.csmonitor.com/USA/Justice/2012/1203/Bullets-vs.-rocks-Border-Patrol-under-fire-for-use-of-deadly-force/(page)/2.

57. Chad C. Haddal, "Attacks on Border Patrol Agents," in *Border Security: The Role of the U.S. Border Patrol* (CRS Report for Congress no. RL 32562, Congressional Research Service, August 11, 2010): 28–29, www.fas.org/sgp/crs/homesec/RL32562.pdf.

58. Elliot Spagat, "Border Patrol Will Continue Killing People Who Throw Rocks," *Huffington Post,* November 13, 2013, Latino Voices sec.

59. Anthony Kimery, "Dangerous Rock Attacks On Border Patrol Agents Are Up; Chopper Brought Down By Rock In '79,"

Homeland Security Today, July 20, 2011, www.hstoday.us/columns/the-kimery-report/blog/dangerous-rock-attacks-on-border-patrol-agents-are-up-chopper-brought-down-by-rock-in-79/56d720dfd2a031fd-9638f6e8123a5ca0.html.

60. Ted Robbins, "Border Killings Prompt Scrutiny over Use of Force," *All Things Considered,* NPR, November 24, 2012, www.npr.org/2012/11/24/165822846/border-killings-prompt-scrutiny-over-use-of-force.

61. Medrano, "Bullets vs. Rocks?"

62. Robbins, "Border Killings Prompt Scrutiny."

63. Spagat, "Border Patrol Will Continue Killing."

64. Interview with a group of children from Anapra, Mexico, and Border Patrol agents, at the wall, in the fall of 2008.

65. Thomas Streissguth, *Bangladesh in Pictures* (Minneapolis, MN: VGS/Twenty-First Century Books, 2009).

66. The Gang of Eight comprised Senators Michael Bennet (D-CO), Richard J. Durbin (D-IL), Jeff Flake (R-AZ), Lindsey Graham (R-SC), John McCain (R-AZ), Bob Menendez (D-NJ), Marco Rubio (R-FL), and Chuck Schumer (D-NY).

67. Andrew Stiles, "Building a Human Wall on the Border," *National Review,* July 2, 2013, www.nationalreview.com/

article/352539/building-human-wall-border-andrew-stiles.

68. Melissa Gaskill, "United States Border Fence Threatens Wildlife," Nature.com, August 2, 2011, www.nature.com/news/2011/110802/full/news.2011.452.html.

69. Anna Lena Phillips, "Don't Fence Me Out: To Protect Wildlife, Barriers to Information Flow between Science and Policy Will Have to Be Made More Permeable," *American Scientist* 97, no. 6 (2009): 454.

70. Gabriela de Valle, "A Green Curtain: Coahuila's Environmental Will and Commitment," in *The Border Wall: Venues, Mechanisms, and Stakeholders for a Constructive Dialogue between the United States and Mexico,* part 3 (Mexico City, MX: Instituto Nacional de Ecología y Cambio Climático, 2009), www2.inecc.gob.mx/publicaciones/libros/606/green.pdf.

71. Good Neighbor Environmental Board (GNEB), "The Potential Environmental and Economic Benefits of Renewable Energy Development in the U.S.-Mexico Border Region" (Fourteenth Reports of the GNEB to the President and Congress of the United States, EPA 130-R-11-001), December 2011, https://www.epa.gov/sites/production/files/documents/english-gneb-14th-report.pdf.

72. Data gathered from U.S. Border Patrol, Southwest Border Sectors, "Southwest Deaths by

Fiscal Year (1998–2015)," www.cbp.gov/sites/default/files/documents/BP%20Southwest%20Border%20Sector%20Deaths%20FY1998%20-%20FY2015.pdf.

73. Spencer S. Hsu, "Border Deaths Are Increasing," *Washington Post*, September 30, 2009, www.washingtonpost.com/wp-dyn/content/article/2009/09/29/AR2009092903212.html.

74. John Doe and Jane Doe are common names for unidentified people in the United States and Canada, but not in other English-speaking countries.

75. Barry Pritzker, *A Native American Encyclopedia: History, Culture, and Peoples*. New York: Oxford University Press, 2000.

76. Tim Gaynor, "Indians Complain Graves Dug Up for Border Fence," Reuters, June 24, 2007, www.reuters.com/article/2007/06/24/us-security-usa-indians-idUSN2216828020070624.

77. Winston P. Erickson, *Sharing the Desert: The Tohono O'odham in History* (Tucson: University of Arizona Press, 1994).

78. Tyche Hendricks, *The Wind Doesn't Need a Passport: Stories from the U.S.-Mexico Borderlands* (Berkeley: University of California Press, 2010).

79. Elders of Ali Jegk Community of the Tohono O'odham Nation, "Return the Remains; Stop the Desecration of O'odham Burial

Grounds," Petition Online, www.petitiononline.com/reburial/petition.html. Accessed April 20, 2014.

80. James S. Griffith, *A Shared Space: Folklife in the Arizona-Sonora Borderlands* (Logan: Utah State University Press, 1995).

81. Ibid.

82. Brady McCombs, "Horse Race Celebrated Sister-City Camaraderie," *Arizona Daily Star*, December 13, 2011, local news sec.

83. Lindsay Eriksson and Melinda Taylor, "The Environmental Impacts of the Border Wall between Texas and Mexico" (working group analysis document, University of Texas Austin, n.d.), www.utexas.edu/law/centers/humanrights/borderwall/analysis/briefing-The-Environmental-Impacts-of-the-Border-Wall.pdf.

84. Mary Emily O'Hara, "Legal Pot in the U.S. Is Crippling Mexican Cartels," *Vice News*, May 8, 2014, https://news.vice.com/article/legal-pot-in-the-us-is-crippling-mexican-cartels.

85. Marcello de Cintio, "Christo and Jeanne-Claude's *Running Fence*," *Elsewhere*, May 3, 2010, https://marcellodicintio.com/2010/05/03/christo-and-jeanne-claudes-running-fence/.

86. Lourdes Medrano, "'Virtual' Border Fence Idea Revived. Another 'Billion Dollar Boondoggle'? (+ video)," *Christian Science Monitor*, March 19, 2014, www.csmonitor.com/USA/2014/0319/

Virtual-border-fence-idea-revived.-Another-billion-dollar-boondoggle-video.

87. Postcommodity is Raven Chacon, Kade Twist, and Cristóbal Martínez.

88. Joe Holley, "Politics, Population Pressure Put Strain on Valley Nature Preserve," *Houston Chronicle*, June 3, 2013, www.houstonchronicle.com/local/native-texan/article/Politics-population-pressures-put-strain-on-4568892.php.

89. Oscar Caseres, "Border Fence Upends a Farmer's Life," *New York Times*, November 27, 2011, www.nytimes.com/2011/11/27/us/border-fence-upends-a-rio-grande-valley-farmers-life.html.

90. Richard Marosi, "Some Angry Texans Are Stuck South of the Border," *Los Angeles Times*, February 28, 2011, http://articles.latimes.com/2011/feb/28/nation/la-na-texas-fence-20110228/2.

91. Edward S. Casey and Mary Watkins, *Up against the Wall: Re-Imagining the U.S.-Mexico Border* (Austin: University of Texas Press, 2014).

92. "Dr. Eloisa Tamez," Faces of the Borderlands, *Borderlands*, Sierra Club, n.d., http://vault.sierraclub.org/borderlands/faces/iframes/tamez.asp.

93. Melissa Montoya, "Local Professor Uses Settlement for Scholarships," *Brownsville Herald*, April 11, 2014, www.brownsvilleherald.com/news/local/article_ce9ac5f0-c120-11e3-a221-001a4bcf6878.html.

94. A setback, in land use planning, is the defined distance that structures must remain from roads, rivers, floodplains, other structures, or any other condition that might need protecting.

95. Rebecca Solnit, *Storming the Gates of Paradise: Landscapes for Politics* (Berkeley: University of California Press, 2007), 105.

96. Stanley D. Brunn, *Engineering Earth: The Impacts of Megaengineering Projects* (Dordrecht: Springer, 2011), 1714.

97. Jason Beaubien, "Border Fence Yields Showdown at Smuggler's Gulch," *All Things Considered,* NPR, February 6, 2009, www.npr.org/templates/story/story.php?storyId=100336089.

98. Peter Rowe, "Repairing Border Wall a Daily Endeavor," *San Diego Union-Tribune,* May 15, 2016, www.sandiegouniontri-bune.com/news/2016/may/15/border-wall-daily-repair/.

A wall was built between Mexico and the United States of America after 9/11 because immigration control and national security became national obsessions. Neither of these problems originated in the borderlands. However, the United States decided that the border was the place where they would be confronted, using the oldest and crudest tools in its geopolitical arsenal: partition and fortification.

Far-distant politicians in Washington, DC, and Mexico City rarely focus on the needs of border people and pay even less heed to their long history of cross-border coexistence. By electing to fight its security battles at the border, the United States is, in effect, relying upon the sacrifices of a small minority of citizens, whose communities have no choice but to bear the brunt of their nation's fears, with little or no capacity for self-determination in such matters. Left to their own devices, border communities suffer the Wall's daily disruptions and indignities, intrusive practices of security forces, ubiquitous infrastructures of control, and a pervasive miasma of mistrust and danger. The assistance offered by federal and local authorities rarely extends beyond military occupation, enhanced surveillance, and pervasive policing.

In the three decades years since the 1986 Immigration Reform and Control Act was passed, over $187 billion has been spent on immigration control and border security. Recent proposals for immigration reform include a provision for $40 billion more to be spent on another 700 miles of walls, plus a doubling of the number of U.S. Border Patrol agents from 20,000 to 40,000. These are irrational proposals because, simply stated, walls won't work.

Walls won't work because the border has long been a place of connectivity and collaboration. The border zone is a permeable membrane *connecting* two countries, where

Monument 122-A, viewed from the Avenida Internacional in Nogales, Sonora. A fortuitous vertical stacking of boundary infrastructure recalls the deep archaeology of the line. The top panel reveals present-day electronic surveillance apparatus; below this is the 1990-era Operation Hold-the-Line fencing (made from recycled aircraft landing mats from the Vietnam War); in the third horizon is a monument from the late-nineteenth-century boundary resurvey; and at its base lies a concrete retaining wall that has been spray-painted with symbols of birth and death characteristic of ancient Mesoamerican cultures.

communities on both sides have strong senses of mutual dependence and attachment to territory. The inhabitants of this "in-between" place—which I call a "third nation"— thrive on cross-border support and cooperation, which have flourished (in diverse forms) over many centuries.

For most of human history, there was no United States of America or Estados Unidos Mexicanos. Both nation-states arrived relatively late on the global scene, and the international boundary separating them is little over a century and a half old. Before the 1848 Treaty of Guadalupe Hidalgo ended the U.S.-Mexican War, the borderlands were an open frontier where our prehistoric ancestors roamed widely over the land in search of sustenance, eventually evolving complex civilizations on a subcontinental scale, with extended kinship, settlement, and trade networks.

After 1848, the frontier became a formal geopolitical boundary between two nation-states. Even though the dividing line had been shifted as a consequence of Mexico's defeat, borderland peoples for the most part remained in place. (Even today, it's common to hear people say: "The border moved, not us.") For decades after the war, they continued shuffling their affiliations and allegiances, all the while absorbing newcomers and reforging connections through intermarriage, trade, and defense. Economic ties between Mexico and the United States intensified during the twentieth century, culminating in explosive economic and population growth along the line which, together with enormous cultural and political changes, created the modern, integrated transborder society. From the long perspective of borderland history, the twenty-first-century Wall is an unprecedented aberration.

Walls won't work because the spaces between Mexico and the United States form a "third nation," essential to the prosperity of both countries. The third nation is not a formal, sovereign nation-state with established international

borders, but it shares many characteristics that justify its designation as a "nation," including shared identities, common history, joint traditions, and ties of language. It is a place where binational lives are being created—organically, readily, and without artifice. Border dwellers readily assert that they have more in common with each other than with their host nations, frequently describing themselves as "transborder citizens." In response to current tensions, most border dwellers have made what adjustments they can, demonstrating yet again the remarkable durability and adaptability that has characterized centuries of coexistence.

The present-day "twin cities" straddling the U.S.-Mexico boundary (such as San Diego–Tijuana and El Paso–Ciudad Juárez) are the most prominent current manifestations of economic and social interdependence that extends back to prehistoric times, through centuries of Spanish colonial occupation, and on to the post-1848 town-building era. Today, ambitious infrastructure plans aim to upgrade twin-city connections, boost international tourism, promote investment and economic development, and construct new and expanded ports of entry at record pace to speed crossing times for vehicles and pedestrians. Many of these transnational cities are among the fastest-growing places in both countries; neither Mexico nor the United States can afford to take long-term actions that jeopardize their prosperity.

Walls won't work, as their creators now concede. During the peak fence-building frenzy, I met a Border Patrol agent and project engineer at Smuggler's Gulch, a deep canyon west of Tijuana, where 1.6 million cubic yards of landfill had been dumped to prevent access to the United States along the canyon. A tunnel had been incorporated into the landfill to permit passage of the canyon stream that still flowed north across the border. Gazing doubtfully at

the passageway that the tunnel had opened up, the agent estimated that it would be no more than a week before migrants started using the tunnel to cross over, and the engineer turned his back on the massive earthworks, sighing, "Ninety-five percent of this is politics."

As long as migrants aspire to the "American Dream" and Mexican labor is needed in the United States, people will cross the border with or without papers. Walls don't work simply because people are too inventive in finding ways over, under, through, and around them. Confronted by burgeoning evidence of the Wall's failings, the U.S. Department of Homeland Security (DHS) now asserts that

The present-day boundary between El Paso and Ciudad Juárez is noteworthy for the complete absence of fortifications. From the left, *panel 1* shows the Casa de Adobe, the recently restored headquarters of Mexican Revolution leader Francisco Madero; *panel 2,* a bust of Madero; *panel 3,* a berm topped with a sign marking the boundary between the two nations; and *panel 4,* the Ancient Monument no. 1.

the Wall was never meant to stop migrants, merely to slow them down so that they could be apprehended more easily. DHS attention is now more focused on interior enforcement away from the border line: for instance, replacing workplace raids and migrant arrests with an employer-focused verification program, or catching up with people who overstay their visas (a large proportion of the undocumented).

I revisited El Paso–Ciudad Juárez in 2011 after most of the fortifications along the land boundary had been completed. Accustomed by now to the militarized gloom in the Wall's shadow, I was surprised to find no fortifications in the vicinity of Monument no. 1, where the land boundary meets the Rio Grande/Río Bravo. Instead, the border is marked there only by a shallow earthen berm with a sign atop it heralding the international boundary line. The ambience on the day of my visit was relaxed, and I chatted amiably with people on the other side, exchanging courtesies in Spanish and English. Nothing impeded communication across the line. Walls were neither present nor needed. Things were as they should be.

The third nation endures; it has strong connecting tissue that no barriers can sunder. The third nation is the place of being and becoming between two nations, inviting us to think and act differently about our joint future. Instead of wasting billions more dollars on walls, why not invest the money in growing the ties between our two countries? The prosperity and well-being of the third nation may yet prove to be the most effective guarantors of our national security and linchpin of a humane immigration policy.

This essay is adapted from Michael Dear, *Why Walls Won't Work: Repairing the U.S.-Mexico Divide* (New York: Oxford University Press, 2013).

Consider the momentous event in architecture when the wall parted and the column became.

—Louis Kahn[1]

Each night in the borderlands, people attempt to cut through the wall with blowtorches, saw into it, or straightforwardly knock it down. Floods, hurricanes, oxidization, and other natural factors are constantly wearing away at the wall, as is the inescapable force of entropy as it perpetually migrates silently over, under, and across the border. Quite literally, "something there is that doesn't love a wall."[2]

In advocating for a reconsideration of the wall, the ideas in this book and the insistence on ending the embargo on multifunctional design at the border are not an endorsement for the construction of more walls, nor should they give wall builders a greater reason for building them. Rather, if design—if architecture—can be smuggled into the reimagining of the existing border wall now, it will put into place several very important conditions that will affect the future of the landscapes, cultures, and bioecologies that it now divides.

If the wall were remodeled to perform a multitude of functions that improved, interacted with, and contributed positively to specific issues found in its immediate context, it could be embodied with new meanings. If the wall were implemented as an important investment both in place and in immigration reform through the act of architecture, the conceptual basis for its existence would be effectively dismantled, encouraging the physical dismantling of those portions of the wall not found to be making concrete contributions to its surrounding environment.

Six

Afterwards

RONALD RAEL

According to the United States–Mexico Health Commission, three of the ten poorest counties in the United States are located in the border area, and two of the ten fastest-growing metropolitan areas in the United States—Laredo and McAllen—are located on the Texas-Mexico border. Due to rapid industrialization, communities on the Mexican side of the border have less access to basic water and sanitation services than does the rest of the nation.[3]

A commitment to multifunctional water, solar, environmental, or social improvements on the border, with the wall itself as the vehicle of delivery, would require that a portion of the vast investment of taxpayer dollars in capital expenditures on the border be maintained. Instead of a future scenario in which walls are dismantled solely in the name of freedom and democracy, the walls designed in response to a much-needed investment in some of the most impoverished and fastest-growing regions in the United States might remain, as would our investment in them, and become the armatures upon which the possibilities of a post-borderwall world can be grafted.

Rather than being viewed as meaningless monuments to an outdated method of dealing with immigration, the remnants of a reconsidered wall might be treated with reverence, reminders of a time of trauma that was overcome through creativity, resilience, and imagination. East Germany and West Germany are in many places indistinguishable from each other, but in some areas the palimpsest of the Berlin Wall remains. The healing of the two cities has been articulated by a scar that continues to be visible in many places in the form of urban parks, museums, and public pedestrian and bicycle trails.

Architect Lebbeus Woods's thoughts on the nature of the scar lend themselves to the wall as well:

> The scar is a deeper level of reconstruction that fuses the new and the old, reconciling, coalescing them, without compromising either one in the name of some contextual form of unity. The scar is a mark of pride and of honor, both for what has been lost and what has been gained. It cannot be erased, except by the most cosmetic means. It cannot be elevated beyond what it is, a mutant tissue, the precursor of unpredictable regenerations. To accept the scar is to accept existence. Healing is not an illusory, cosmetic process, but something that—by articulating differences—both deeply divides and joins together.[4]

The wall, like the scar it will leave, must be accepted—not only as a political symbol of security but also as the latent connective tissue between the United Mexican States and

Los Estados Unidos de América. There are fourteen major sister cities along the border whose urban, cultural, and ecological networks have been bifurcated by the wall.[5] With the population in these urban areas expected to grow to over 20 million inhabitants over the next decade, the long-term effects of the wall's construction must be carefully considered now in order to anticipate the consequences of its incision into a context of rapid growth and massive migratory flows.[6]

If an appeal is being made to tear down *this* wall, as it has been demanded by others, then what will replace it in the future must absolutely be designed now.[7] However, as has become unexpectedly clear just as this book goes to press, we find ourselves in a moment of great uncertainty regarding the future of the wall and our relationships with Mexico, its citizens, and with those who culturally identify with both nations. Despite the media circus during the time this book was being written, I never gave Donald Trump more than a single footnote, believing that his divisive and bombastic campaign promises would amount to little more than the inconsequential and inflammatory ideas of another also-ran in the history of American politics. But today we are faced with the reality of President-elect Donald Trump's primary promise to voters: to wall off the entire southern border with Mexico with structures far more aggressive than those already in place—a plan that has been estimated to cost $25 billion dollars.[8]

Notwithstanding the massive problems the construction of the wall has created, especially over the past 10 years, the obvious lessons of why walls don't work, and won't (as Michael Dear affirms), have not yet been learned, and a large percentage of American citizens continue to overwhelmingly support their construction. And while Trump has not yet built his "great wall" literally, he certainly has done so figuratively, both in the borderlands between the citizens of the U.S. and Mexico, and within our own body politic. The lines

Sister cities collapsed along the border (top to bottom): Tecolote/Somerton; Agua Prieta/Douglas; Puerto Palomas/Columbus; Ojinaga/Presidio; Ciudad Acuña/Del Rio; El Francés/Rio Bravo; Ciudad Miguel Alemán/Roma; Ciudad Camargo/Rio Grande City; Ciudad Gustavo Díaz Ordaz/Sullivan City; Ciudad Río Bravo/Donna; Nuevo Progreso/Weslaco; El Control/La Feria; Ramírez/Los Indios.

MEXICO

UNITED STATES

Agua Prieta

Douglas

Presidio

Ojinaga

El Francés

Rio Bravo

Roma

Ciudad de Miguel
Alemán

Ciudad Camargo

Rio Grande City

Ciudad Río Bravo

Donna

Los Indios

Ramírez

that define racial, political, and nationalistic differences have pushed many to further extremes since the election. This book was created to propound strategies for dismantling and transforming the steel and concrete that divides us. But a re-framing of our borderwall as architecture is but one way of illustrating an ever more important goal: we must also work toward finding creative methods to raze the walls of racism, misogyny, homophobia, poverty, religious persecution, and fear that now more than ever define us as citizens of these divided states.

1. Quoted in John Lobell, *Between Silence and Light: Spirit in the Architecture of Louis I. Kahn* (Boulder, CO: Shambhala Publications, 1979), p. 42.

2. Robert Frost, "Mending Wall," line 1.

3. United States–Mexico Border Health Commission, "Border Region," http://www.border-health.org/border_region.php.

4. Lebbeus Woods, *Pamphlet Architecture 15: War and Architecture* (New York: Princeton Architectural Press, 1993), 31.

5. In addition, the Tohono O'odham Nation and Sonoyta, Sonora, are linked in a trinational plan. See "Cross Border Contingency Plans for U.S.-Mexico Sister Cities," Border 2020, U.S. Environmental Protection Agency, n.d., https://www.epa.gov/border2020/cross-border-contingency-plans-us-mexico-sister-cities.

6. Migration between the United States and Mexico is not one-sided: the U.S. State Department reports that approximately 1 million American citizens live in Mexico (http://www.state.gov/r/pa/ei/bgn/35749.htm), and U.S. tourist visits to Mexico numbered over 20 million in 2015 (http://www.nytimes.com/2015/01/11/travel/where-will-americans-travel-in-2015).

7. Other calls have been made to tear down the wall between the U.S. and Mexico—notably Michael Dear, "Mr. President, Tear Down This Wall," *New York Times*, March 11, 2013, Opinion sec., http://www.nytimes.com/2013/03/11/opinion/mr-president-tear-down-this-wall.html; and Teddy Cruz, "Teddy Cruz to Ted Cruz: Tear Down That Wall," *Creative Time Reports*, November 3, 2014, http://creativetimereports.org/2014/11/03/teddy-cruz-to-senator-ted-cruz-tear-down-that-wall/. The demand "Tear down this wall" was made famous on June 12, 1987, when Republican president Ronald Reagan challenged the president of the Soviet Union, Mikhail Gorbachev, to dismantle the Berlin Wall in a speech commemorating the 750th anniversary of Berlin.

8. Trump has suggested several times that Mexico will pay for the wall despite former President Vicente Fox stating that Mexico is not "going to pay for that fucking wall," and Mexican President Enrique Peña Nieto's assertion that Mexico "will never pay for a wall."

Sadness is but a wall between two gardens.

—**Kahlil Gibran**

Adler, Rudy, Victoria Criado, and Brett Huneycutt. *Border Film Project: Photos by Migrants and Minutemen on the U.S.-Mexico Border*. New York: Abrams, 2007.

Andreas, Peter. *Border Games: Policing the U.S.-Mexico Divide*. Ithaca: Cornell University Press, 2000.

Brown, Wendy. *Walled States, Waning Sovereignty*. New York: Zone Books, 2010.

Casey, Edward S., and Mary M. Watkins. *Up against the Wall: Re-imagining the U.S.-Mexico Border*. Austin: University of Texas Press, 2014.

Chávez, Sergio R. *Border Lives: Fronterizos, Transnational Migrants, and Commuters in Tijuana*. New York: Oxford University Press, 2016.

Chertoff, Michael. *Homeland Security: Assessing the First Five Years*. Philadelphia: University of Pennsylvania Press, 2009.

Clarkson, Stephen, and Matto Mildenberger. *Dependent America? How Canada and Mexico Construct U.S. Power*. Toronto: University of Toronto Press, 2011.

Córdova-Leyva, Roberto, and Héctor Manuel Lucero Velasco. *Al Filo de la Línea*. Mexicali, Baja California: Centro de Estudios Culturales UABC Museo, 2004.

Cruz, Teddy. "Teddy Cruz to Ted Cruz: Tear Down That Wall." *Creative Time Reports,* November 3, 2014, http://creativetimereports.org/2014/11/03/teddy-cruz-to-senator-ted-cruz-tear-down-that-wall/.

Dear, Michael J. *Why Walls Won't Work: Repairing the U.S.-Mexico Divide*. New York: Oxford University Press, 2015.

Del Real, Patricio. "Gone Fencing: Architects Tackle the U.S.-Mexico Border." Academia. edu., 2007, www.academia.edu/2478419/ Gone_fencing_Architects_tackle_the_ Us-Mexico_Border.

Di Cintio, Marcello. *Walls: Travels along the Barricades*. Berkeley, CA: Soft Skull Press/ Counterpoint, 2013.

Erickson, Winston P. *Sharing the Desert: The Tohono O'odham in History*. Tucson: University of Arizona Press, 1994.

Griffith, James S. *A Shared Space: Folklife in the Arizona-Sonora Borderlands*. Logan: Utah State University Press, 1995.

Iglesias-Prieto, Norma. *Beautiful Flowers of the Maquiladora: Life Histories of Women Workers in Tijuana*. Austin: University of Texas Press, 1997.

Loyd, Jenna M., Matt Mitchelson, and Andrew Burridge. *Beyond Walls and Cages: Prisons, Borders, and Global Crisis*. Athens: University of Georgia Press, 2012.

Maril, Robert Lee. *The Fence: National Security, Public Safety, and Illegal Immigration along the U.S.-Mexico Border*. Lubbock: Texas Tech University Press, 2011.

Misrach, Richard, Guillermo Galindo, and Josh Kun. *Border Cantos*. New York: Aperture, 2016.

Pritzker, Barry. *A Native American Encyclopedia: History, Culture, and Peoples*. New York: Oxford University Press, 2000.

Rael, Ronald. "Commentary: Border Wall as Architecture." *Environment and Planning D: Society and Space* 29 (2011): 409–20.

Schlyer, Krista. *Continental Divide: Wildlife, People, and the Border Wall*. College Station: Texas A & M University Press, 2012.

Secure Fence Act of 2006 (H.R. 6061). 109th Congress (2005–2006). www.congress.gov/ bill/109th-congress/house-bill/6061.

Solnit, Rebecca. *Storming the Gates of Paradise: Landscapes for Politics*. Berkeley: University of California Press, 2007.

Sorkin, Michael. *Against the Wall: Israel's Barrier to Peace*. New York: New Press, 2005.

St. John, Rachel. *Line in the Sand: A History of the Western U.S.-Mexico Border*. Princeton, NJ: Princeton University Press, 2011.

Taylor, David, Luis Alberto Urrea, and Hannah Frieser. *David Taylor: Working the Line*. Santa Fe, NM: Radius Books, 2010.

Vallet, Élisabeth. *Borders, Fences and Walls: State of Insecurity?* Border Regions Series. Surrey, UK; Burlington, VT: Ashgate, 2014.

Woods, Lebbeus. *Pamphlet Architecture 15: War and Architecture*. New York: Princeton Architectural Press, 1993.

Weber, Cynthia. "Civilians." Chap. 3 in *'I Am an American': Filming the Fear of Difference*. Bristol, UK: Intellect, 2011. Distributed by University of Chicago Press.

Weyant, Glenn. *SonicAnta*. www.sonicanta. com.

Woods, Lebbeus. *Pamphlet Architecture 15: War and Architecture*. New York: Princeton Architectural Press, 1993.

The Author

Ronald Rael is an associate professor of Architecture and Art Practice at the University of California, Berkeley. His first book, *Earth Architecture* (Princeton Architectural Press, 2008), is a history of building with earth in the modern era to exemplify contemporary uses of the oldest building material on the planet. In 2014 his creative practice, Rael San Fratello (with architect Virginia San Fratello), was named an Emerging Voice by the Architectural League of New York, one of the most coveted awards in North American architecture. He grew up in the high alpine desert of Colorado's remote San Luis Valley , the former frontier between the United States and Mexico before 1848, where the descendants of that third nation still thrive. He lives in Oakland, California, with his wife and son.

Contributors

Teddy Cruz is recognized internationally for his urban research of the Tijuana–San Diego border, advancing border immigrant neighborhoods as sites of cultural production from which to rethink urban policy, affordable housing, and civic infrastructure. He is Professor of Public Culture and Urbanism at the University of California, San Diego, and principal of Estudio Teddy Cruz + Forman, a research-based political and architectural practice.

Michael Dear is Emeritus Professor of City and Regional Planning in the College of Environmental Design at the University of California, Berkeley, and Honorary Professor in the Bartlett School of Planning at University College London. His most recent book, *Why Walls Won't Work: Repairing the U.S.-Mexico Divide*, published by Oxford University Press in 2015, was awarded the Globe Prize for Geography in the Public Interest by the Association of American Geographers.

Marcello Di Cintio is the author of three books including *Walls: Travels along the Barricades,* which won the 2013 Shaughnessy Cohen Prize for Political Writing and the City of Calgary W. O. Mitchell Book Prize. Di Cintio's writing can also be found in publications such as *The Walrus*, *Canadian Geographic*, *International New York Times*, *Condé Nast Traveler,* and *Afar*. He has been writer-in-residence with the Palestine Writing Workshop and a featured instructor at the 2015 Iceland Writers Workshop. His current book project, *Pay No Heed to the Rockets: Palestine in the Present Tense*, will be published in 2017. Di Cintio lives in Calgary, Canada.

Norma Iglesias-Prieto, a transborder scholar, is a professor in the Department of Chicana and Chicano Studies at San Diego State University and a researcher at El Colegio de la Frontera Norte. Her thirty-three years of academic experience is anchored in border studies, with a focus on art, media production, and other cultural processes on the U.S.-Mexico border. She is the author of five books, including *Beautiful Flowers of the Maquiladoras* (1985; 1997 in English) and *Emergencias: Las artes visuales en Tijuana* (2008).

San Fratello. MOCK WALLS: (58) Catherine D'Ignazio. FIELD OF
DREAMS: (59) courtesy U.S. Customs and Border Protection; (60)
Diane Cook and Len Jenshel/*National Geographic* Creative; (61),
(62) Rael San Fratello. TEETER-TOTTER WALL: (63) Rael San Fratello;
(64) Rael San Fratello, drawn on the original plat of the dividing
line between the United States and Mexico. WILDLIFE WALL: (65),
(66) Rael San Fratello; (67) Rael San Fratello, drawn on the orig-
inal plat of the dividing line between the U.S. and Mexico. FOREST
WALL: (68) Nature Conservancy/API; (69) Rael San Fratello. SOLAR
WALL: (70), (71), (72), 73), (74) Rael San Fratello. HOT WATER
WALL: (75) Rael San Fratello. LIFE SAFETY BEACON: (76), (77) Rael
San Fratello. WALL OF DEATH: (78) API; (79) © Tomas Castelazo,
www.tomascastelazo.com / Wikimedia Commons / CC-BY-SA-3.0.
CEMETERY WALL: (80) Rael San Fratello. HORSE RACING: (81) photog-
rapher unknown; (82) Rael San Fratello, drawn on the original
plat of the dividing line between the U.S. and Mexico. LIGHT WALL:
(83) Image courtesy of the Earth Science and Remote Sensing
Unit, NASA Johnson Space Center. GREENHOUSE WALL: (84) Rael
San Fratello; (85) Rael San Fratello, drawn on the original plat
of the dividing line between the U.S. and Mexico. GALLERY WALL:
(86) Norma Iglesias-Prieto. VIRTUAL WALL: (87) courtesy U.S.
Customs and Border Protection. FLOATING WALL: (88) David McNew
/ Getty Images; (89) Rael San Fratello; (90) Postcommodity.
GATED COMMUNITIES: (91) Don Bartletti/*Los Angeles Times.* HOUSE
DIVIDED: (92) Rael San Fratello; (93) Richard Misrach; (94), (95),
(96), (97) Rael San Fratello. EARTH WALL: (98) Romel Jacinto. FIRE
WALL: (99) Manuel Coppola/*Nogales International.* INVISIBLE WALL:
(100) Courtesy of Ana Teresa Fernández and Gallery Wendi Norris.
MONUMENTAL WALL: (101) Jacobo Blanco, *Vistas de los Monumentos
a lo Largo de la Línea Divisoria entre México y los Estados Unidos
de El Paso al Pacifico,* 1901; (102) Rael San Fratello; (103) David
Taylor. LABYRINTH WALL: (104), (105) Rael San Fratello.
5 Why Walls Won't Work: Monument 122-A © 2003 by Michelle
Shofet; El Paso–Ciudad Juárez boundary © 2011 by Michael Dear.
6 Afterwards: Drawing by Emily Licht.

Index of Recuerdos

p. 77

p. 84

p. 87

p. 105

p. 151

p. 43

p. 56

p. 58

p. 61

p. 90

p. 93

p. 116

p. 121

p. 173